images *of* nature

The Art of India

Judith Magee

Published by the Natural History Museum, London

First published by the Natural History Museum
Cromwell Road, London SW7 5BD
© Natural History Museum, London, 2013

ISBN 978 0 565 09310 5

A catalogue record for this book is available from the British Library.

Designed by Mercer Design, London
Reproduction by Saxon Digital Services
Printed by 1010 Printing International Limited

Front cover: *Macaca silenus*, lion-tailed macaque
Back cover: *Porphyrio porphyrio policocephalus*, purple swamphen
Back flap: *Bungarus fasciatus*, banded krait
Contents page: *Datura metel*, angel's trumpet/devil's trumpet
All images © NHMPL

Contents

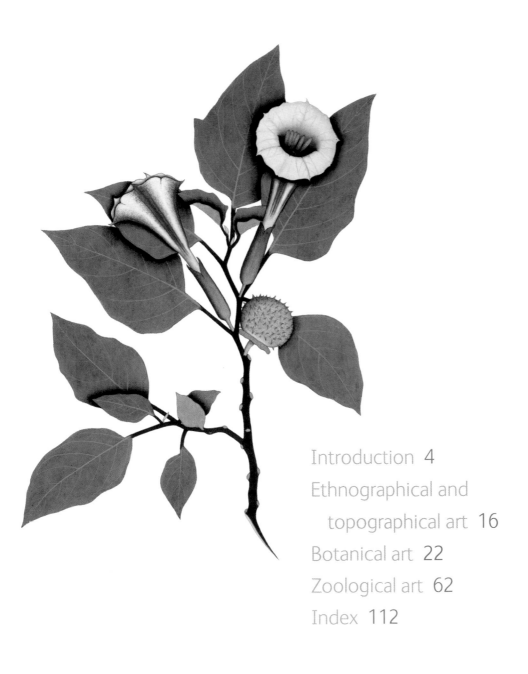

Introduction

India has one of the most diverse natural histories in the world. Recording and studying this natural history has continued over many centuries but in the late eighteenth and throughout the nineteenth centuries this work was dominated by those working for the British East India Company. Documenting the plants and animals and the relationship between them took many forms and one of the most aesthetically pleasing was that of drawing. There is a rich and wide-ranging collection of Indian drawings from this period in the Library of the Natural History Museum. They originate from a variety of sources that include individual artists and collectors, as well as organised studies of Indian natural history in the pursuit of science, commerce and politics. Most of the drawings are watercolours and range from strict scientific botanical and zoological illustrations through to depictions of colourful artefacts and trinkets purchased in local markets. Within this vast collection are some little known, and even less researched, gems of natural history art. They represent small pieces of an extensive canvas that, together with the larger and more well-known collections, contribute to the complex picture of British presence in India.

European settlement in India began in earnest in the early sixteenth century when the Portuguese established trading 'factories' or warehouses in the west, along the Malabar Coast and Goa. The main cargo transported to Europe was spices, particularly black pepper from Kerala. Portuguese dominance continued until the early- to mid-seventeenth century when the Dutch took possession of several islands and regions in south India, while the British established bases in Surat and later Bombay. Dutch and British presence in south Asia was directed through their respective East India Companies whose main function was commercial trade.

By the eighteenth century France and Denmark had also established trading bases in India but it was Britain that came to dominate, squeezing out rival Europeans through military action and skilful negotiation of treaties with local Indian rulers. The history of the British in India is one of gradual geographical expansion through greater military activity leading finally to administrative, political and colonial rule.

The advancement of British presence in India and its empire building was dependent on an assortment of changing political and economic conditions; principally the decline of Mughal rule and the fragmentation of many regions into smaller regional states. The relationship between Indians and British was complex, with a vast network of people and political, administrative and economic systems that interconnected and at times were interdependent, each influencing and directing the relationships in various ways. This resulted in an extensive exchange of experiences, practices and knowledge. For the British a significant element in having greater knowledge and understanding of India was natural history research.

The priorities of the British East India Company were always trade, commercial expansion and increasing returns for shareholders. Nevertheless, the Company's involvement in researching the natural history of India, which developed in tandem with its control of ever-increasing geographical areas, was an important one. There were many strands to this involvement, ranging from individual officers pursuing their own passions for botany and zoology, to the Company's growing realisation that to manage and profit from the vast land over which it held political and administrative control, required knowledge of its plants, animals, agricultural practices and forestry. Associated with the need to manage nature was the idea of progress, which for many brought cultural and social advancement as well as economic benefits. For both the company and the individual there was a reliance on the expertise of the indigenous population. There was an enormous wealth of local knowledge that could be tapped into, which ranged from an understanding of what grew successfully in local gardens through to land and forest management on a large scale. It included knowledge of the local flora and fauna, their uses, particularly for medicinal purposes, and their dangers, such as poisonous plants and animals. Europeans were also reliant on the local people to act as guides on surveys and expeditions. Interpreters served a vital role and although a number of Company officers, such as William Sykes (1790–1872) and Brian Hodgson (1800–94), could speak and even write one or more Indian language, they, like most, still relied on native speakers who had knowledge of the vernacular names of plants and animals. Their contribution added significantly to the understanding and development of natural history knowledge and was therefore indispensable.

Ornithoptera priamus,
Priam's birdwing butterfly

The male of this species is more colourful than the female, its dazzling wings range from iridescent green to blue. The genus is not native to India but of Australasian origin.

Ditmas
Watercolour
c. 1840
231 x 187 mm

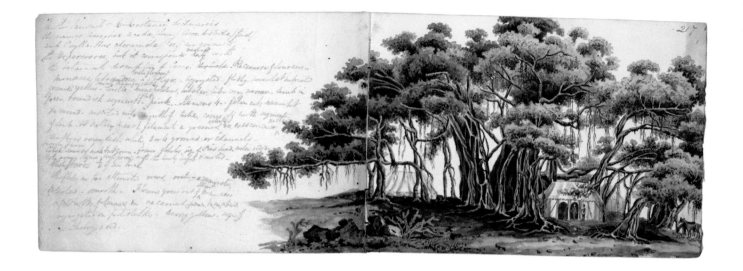

Ficus benghalensis,
banyan tree

The Banyan is the national
tree of India and is regarded
as sacred. Its stunning feature
is the aerial roots that grow
down to the ground becoming
woody trunks.

Fidlor/Sykes Collection
Watercolour
1825
130 x 370 mm

Directly related to this understanding of Indian natural history was the illustration of plants, birds, insects and other animals for study. A talented artist was invaluable, as an accurate depiction of a species could be the key to identifying and classifying it. Some of the artists were Europeans trained in draughtsmanship. Some had a natural flair for drawing such as Llewellyn Fidlor (fl.1824–31) who had been a professional artist before joining the Company. However, the vast majority of artists were Indians, employed directly by the Company or commissioned by individual officers to produce drawings.

Most of the drawings originating under the auspices of the East India Company were collected by those directly involved in science, many of whom were from the medical profession. Some of the pioneering heroes of Indian botany like William Roxburgh (1751–1815), John Fleming (1747–1829) and Nathaniel Wallich (1786–1854) were physicians and spent much of their time employed in running the three Company botanic gardens in India. Their interests in natural history led them to commission and accumulate large collections of botanical illustrations and these form some of the most significant visual records of Indian flora of the early nineteenth century. Other major collections were built by men from the Indian Civil Service like Brian Houghton Hodgson, while Thomas Hardwicke (1755–1835) and William Sykes came from military backgrounds. There are some collections not directly associated with the Company which give a more personal view of India. A good example is the collection of Olivia Tonge (1858–1949) who travelled through India in the early twentieth century. Another is a volume

produced in 1750 of plants from Anjengo by Saluadores (fl. 1750), a Portuguese-speaking Indian, in which he describes the medicinal properties of each of the plants depicted and provides instructions on how they should be administered.

Natural history becomes popular

Interest in natural history had become the pastime of many a wealthy gentleman during the eighteenth century. By the early nineteenth century this interest had burgeoned and collecting and studying plants and animals was fashionable among all layers of society. With the dominance of Linnaeus's classification system it was now possible to bring order to and make sense of the natural world. The fascination with the study of natural history was not solely down to individual curiosity; there were also economic considerations. The industrial revolution and expansion of world trade were reliant on the discovery of new foods and new medicinal- and timber-producing plants. For the East India Company, the growing of plants of economic value was essential and many newly discovered plants from around the world were introduced into the Company's gardens in India, the Cape and in the Caribbean. Knowledge of natural history was disseminated through an expanding publishing industry, and advances in paper making and printing resulted in a wealth of natural history journals starting up.

Scholarly interest in the history, arts, science and literature of India by a number of Company officers led to the founding of the Asiatick Society in 1784, later known as the Asiatic Society of Bengal. Company servants were encouraged to engage in the study of natural history and publish their findings. Many employees who returned to Britain maintained an interest in Indian culture and natural history and in 1823 the British Asiatic Society was established, providing yet another vehicle to publish papers on Indian natural history. The collecting of antiquities, artistic and cultural objects and artefacts of all kinds, together with specimens of minerals, birds, insects, animals and plants, had became so extensive that in 1801 the Company established a library and museum in its headquarters in Leadenhall Street in London. In addition to the founding of the Asiatic Society and the museum, there was more importantly the establishment of botanical gardens in the key regions of British India. The largest of these was at Sibpur, close to Calcutta and commonly referred to as the Calcutta garden. This garden also maintained a large herbarium of dried specimens. It was from here that William Roxburgh and Nathaniel Wallich, two long-serving superintendents of the garden, conducted a programme of commissioning artists to illustrate the plants growing there.

Natural history illustration

A drawing is often of greater worth than a specimen as it can record details not seen in a dried plant, a skin or an animal preserved in spirits. For the naturalist, drawing is a valuable activity in learning about the subject and by the late eighteenth century strict conventions existed for scientific drawing. All important in conveying information about the subject are the morphological features of the plant or animal – the structure, form, colour and pattern. For botanical art the standard practice is also to include the key characteristics for identification – the number and structure of the male and female parts of the plant, which are often magnified on the illustration. In zoological illustration anatomical features are also often included. It is important to capture motion, behaviour and character and this requires observing the subject in its living habitat. Illustrating living, moving animals and birds presents considerable challenges and so more often than not the drawing is made from a dead specimen. Consequently, some of the greatest natural history artists were those with excellent observational skills and who were also some of the finest field naturalists. The aim for both botanical and zoological art is to be typical of the species, with which all others of its kind can be compared. This means eliminating any distracting elements and for this reason the subject is conventionally placed on the page in isolation, without any context.

This convention of illustrating specimens was peculiar to Europe. It was in line with Linnaean classification and with the development of European science. Elsewhere in the world nature was depicted quite differently. So when Indian artists, trained in traditional methods influenced by Mughal miniature painting, were employed to draw a scientific specimen they had to change and adapt their art. Most of the artists working at the botanic gardens received instructions on how to draw in a scientific style and all their work was closely supervised.

Traditional Indian art was highly stylised and featured bright colours and strong outlines. Layer upon layer of thick gouache (body colour) was applied to the paper and the paint was burnished after each application. This allowed the artist to then almost engrave fine lines within the paint, creating a patina that captured the iridescence of bird feathers and fish scales. Some of the works in the collection are typical of this style but the vast majority of Indian artists adopted a less flamboyant approach and used watercolour in a similar way to the illustrated books brought in from Europe as examples. Most paintings are unsigned and little is known about the few artists who are identified, Indian or European.

Among the collections several almost identical drawings can be found. These copies were either made at the same time by the one artist or commissioned at a later time by another collector using a different artist. It was common for those commissioning drawings to present and receive drawings of plants and animals that were of particular interest to them as gifts. This exchange took place not only within the circles of Company employees in India but also those based elsewhere. John Reeves, a tea inspector based in Canton, China, exchanged drawings with several other naturalists including Thomas Hardwicke in India. This exchange also included specimens and so it is not uncommon to find drawings of plants and animals native to countries as far away as Australia and South America in an individual's collection.

Collectors and artists – botany

Among the earliest drawings by Indian artists are the ones commissioned by James Kerr (1738–82) between 1774 and 1782 when he was stationed in Dacca, Bengal (now Dhaka, the capital of Bangladesh). Kerr was a Company surgeon and before moving to Bengal had been resident in Bihar where he took a particular interest in the cultivation of opium and reported his observations of its debilitating effects. His collection of scientifically accurate drawings of plants is an early example of Linnaean-style drawings.

The founding of the Sibpur botanical garden outside Calcutta in 1787 allowed others to follow the model established by Kerr of employing artists to reproduce systematically images of local plants and of those introduced to the garden. Dr William Roxburgh was the superintendent of the garden from 1793 until his retirement in 1813 and he established a series of programmes that transformed the gardens, making them the centre for acclimatising newly-introduced and useful plants from around the world. He organised collecting expeditions to various parts of Southeast Asia and supervised the scientific research of plants and the painting of them by a group of paid artists. These paintings became know as Roxburgh's Icones and copies of many of them were made for friends and the India Museum in London. Another collection, with over eleven hundred beautifully executed botanical drawings, and believed to have been made by Roxburgh's artists is that of John Fleming. He, like Roxburgh, was born in Scotland and entered the medical profession, qualifying as a surgeon. Also like Roxburgh, Fleming was a keen naturalist and took particular interest in medicinal plants, writing the first published *Catalogue of Indian Medicinal Plants and Drugs* (1810).

Dr Patrick Russell (1727–1805) was another Scottish surgeon who joined the East India Company, serving as the Company botanist in the Carnatic region in south India. Here he extended his researches beyond botany to include all areas of natural history. He published works on plants, fish and poisonous snakes of the Coromandel Coast. This was the first work of its kind and the costs of publication were met by the Company. It was Russell who proposed the publication of the *Plants of the Coast of Coromandel*, a work he wrote the preface for together with William Roxburgh, published between 1795 and 1820 in 12 parts.

It took several years to find a suitable replacement for Roxburgh after he retired in 1813. The post of superintendent to the Calcutta gardens was offered to Nathaniel Wallich in 1817, who, not counting a few years of absence due to ill health remained until 1846. Wallich was born in Copenhagen where he trained as a surgeon. He travelled to India to serve as Surgeon to the Danish factory at Serampore and after the British took military control of the area in 1808 he entered the service of the Company. Wallich continued the practice of commissioning artists to produce illustrations of the flora of India and like Roxburgh assigned identifications and descriptions of the plants drawn. In 1820 he contributed to and helped publish Roxburgh's *Flora Indica*.

The Calcutta garden was the largest and remained the primary botanical establishment for the East India Company. The second most important garden for the Company in the Indian subcontinent was at Saharunpore in Uttar Pradesh. Originally a Mughal garden dating from the mid-eighteenth century it was taken over by the Company in 1818 and became the centre for studying plants from north India and the Himalayas, particularly those of medicinal value. In 1823 it came under the charge of John Forbes Royle (1799–1858) who, up until his retirement in 1831, adopted the practice of those at the Calcutta garden of employing artists. He also borrowed the Calcutta team of artists when Wallich was on leave in England. Botanical illustration continued at the garden through to the late 1850s despite major restrictions in funding by the Company for such work.

Collectors and artists – Zoology

Some 12 miles from the Calcutta garden was Dum Dum, the home of the Bengal Artillery of the East India Company army. It was here that Thomas Hardwicke was stationed for several years. He joined the Company as a cadet at the age of 22 and rose to the rank of Major General by 1819.

Rhododendron arboretum, rhododendron

This rhododendron is the national plant of Nepal. It was first collected by Thomas Hardwicke on an expedition to the Siwalik Hills in 1796 and became the first Indian rhododendron to be introduced to English gardens.

Hardwicke
Watercolour
c. 1796
480 x 296 mm

He took part in several important military campaigns, including the second and third Mysore wars in the late eighteenth century. He retired in 1823 having spent the best part of 45 years in India. Hardwicke was one of many amateur naturalists in India and his particular interest was zoology. His appetite for collecting specimens, drawings, literature and information about Indian zoology was insatiable. When not on active duty he occupied his time studying and collecting natural history specimens, so that by the end of his life he had amassed one of the largest Indian natural history collections of all time.

Hardwicke conducted several expeditions to Kashmir and the Siwalik Hills in the Himalayas and to Betul in Madhya Pradesh. He discovered new plants including the *Rhododendron arboretum*, wrote papers about his finds and had drawings made of plants and animals from these regions. He employed a host of Indian and European artists to work for him. Many of the drawings he had made were given or lent to friends, some of them being copies of originals held in his own collection. Surprisingly few drawings from his collection were published, the exception being those selected by him for John Gray's *Illustrations of Indian Zoology*, 1830. Hardwicke was an active member of the Bengal Asiatic Society and served as its vice president from 1820 to 1822. When he returned to England he opened his house as a museum to exhibit his collections and when he died he bequeathed the collection to the British Museum, now the Natural History Museum.

Ornithological art has always been one of the most popular pastimes for amateurs and professionals, and a pastime often associated with those who were keen sportsmen and who spent a great deal of time shooting birds. Within Hardwicke's collection bird drawings dominate, as they do with Brian Houghton Hodgson's collection. Hodgson was an enthusiast for studying and collecting birds and bird paintings. During his long lifetime

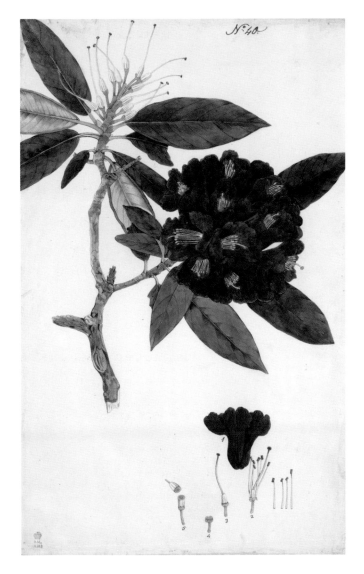

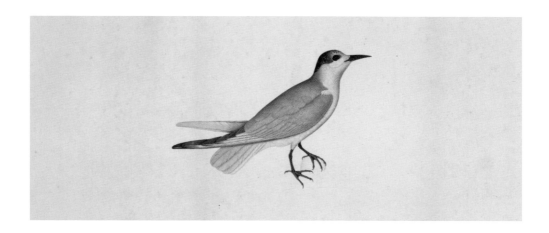

Sterna sp., tern

Many of the artists employed by Lady Impey, wife of the Chief Justice of the Supreme Court of Calcutta, had been trained in the Mughal miniature tradition. By the mid-eighteenth century patronage was greatly reduced so artists travelled from Delhi or Patna to Calcutta to seek work from the British and many adapted their work to a more European style.

Sheik Zayan al-Din/Impey Collection
Watercolour
1781
516 x 748 mm

he published many scientific papers and made a significant contribution to the knowledge of northeast Indian ornithology.

Hodgson had joined the East India Company civil service at the age of 15 and spent two years at the Company College at Haileybury in England. He then travelled to India and continued his education for a further 12 months at the Fort William College in Calcutta. Here he was a pupil of the economist Thomas Malthus and won prizes for his achievements in several subjects, excelling in Indian languages. Poor health led to his transfer from Calcutta to the Himalayas where he spent the best part of 40 years. He rose to become the British Resident Minister of Kathmandu in Nepal. After his retirement in 1844, and a short break in England, he lived in Darjeeling, finally departing India for good in 1858.

Throughout his time in the Himalayas, Hodgson immersed himself in the culture of the region, developing a scholarly knowledge of the languages, law, religion and politics. He studied Buddhist texts and architecture and wrote about the different ethnic and cultural groups. Equal to his cultural studies was his interest in natural history, particularly ornithology. When in Nepal, he spent much of his time as a field naturalist in the Kathmandu Valley, observing birds, their behaviour and their habitat. In addition to making scholarly studies he collected a vast amount of natural history specimens as well as manuscripts in Sanskrit and other south Asian languages. He also amassed an immense number of drawings, the vast majority by Indian artists in his employ. Rajman Singh (fl. 1820–60) became Hodgson's main artist and moved with him from Kathmandu to Darjeeling. Singh was a Nepalese artist trained in the traditional style of religious paintings on cloth, Buddhist manuscripts and prayer books. He became the most sought-after

artist in the Himalayan region and contributed to the collections of many European collectors stationed in Nepal and north India.

The study of Himalayan fauna was in its infancy when Hodgson embarked on his work of collecting, describing and commissioning drawings. Many new species of birds were described by Hodgson and he is also responsible for discovering 22 new species of mammals from Nepal, Tibet and Darjeeling. Hodgson returned to England in 1858 though his interest in Indian culture and natural history continued until his death in 1894.

A less well-known name associated with Indian natural history is William Henry Sykes, who joined the military service of the East India Company in 1803. Sykes rose to the rank of Lieutenant Colonel after considerable active service. In 1824 he was appointed Statistical Reporter to the Bombay Government for the purpose of carrying out a survey in the Deccan plateau in southern India. He was instructed to complete a census of the population and carry out statistical and natural history research. Sykes spent seven years travelling through the region, observing and collecting specimens and information. Accompanying Sykes on his travels was a young soldier from the Bombay Artillery, Bombardier Llewellyn Fidlor. He had been assigned to Sykes as his draughtsman and was described by him as a young man of 'considerable talent in coloring and delineation'. Fidlor is responsible for many of the beautiful drawings that accompany the report.

Sykes completed his report in 1831, giving details of the flora and fauna of the region together with a survey of the agricultural practices carried out by the local farmers. Within the text are a scattering of illustrations that are copies from a series of drawing books made during his travels. The drawing books contain watercolours over pencil sketches and many are enhanced with gouache and gum Arabic. Sykes explained that the drawings had been 'examined, and corrected by myself when necessary both in the pencil and in the color. Errors therefore have been as carefully guarded against as possible'. All the subjects of the drawings are 'on a scale with nature by actual measurements'. The plants depicted are beautiful and delicate, detailing significant parts, which are often magnified, for identification purposes. The animals are exquisitely drawn and include all orders from mammals, insects, birds, fish and reptiles. There are a few sumptuous landscape scenes including geological and geographical features in association with the lush vegetation. However, some of the most fascinating and attractive drawings from this collection are those depicting agricultural implements, their complex mechanisms and uses. These are laid out in intricate and precise diagrams and finished to perfection.

Sykes gathered his information 'direct from the people & from personal examination of village or other public papers'. He was able to write and speak the Mahratha language and added local names both to his text and the drawings. Sykes also employed several Indians who supplied the Sanskrit and Hindustani names.

Independent collectors and artists

The collecting and commissioning of Indian natural history artwork was not restricted to those employed by the East India Company. By 1750 the British had a well-established trading fort in Anjengo, now known as Anchuthengi, in Kerala on the west coast of India, and controlled much of the region. It had formerly been a Portuguese settlement and many educated Indians continued to speak Portuguese and use the language in scholarly and instructive works. A curious example of this is an early work by Saluadores, who produced a magnificent manuscript of Indian plants with medicinal properties. *The Declaracao da Aruores, Arbustas, Plantas, Grapadeiras* is a pharmacopoeia produced in 1750 and relates to the local plants used by the inhabitants of Anjengo. In addition to the drawing of each plant, information is given on what part of the plant is used for healing purposes together with instructions on their preparation and application. Saluadores was based at the hospital in Anjengo but it is not known for whom the work was made.

Many Europeans, who wished to build their own personal collections, commissioned independent pieces of artwork. Although starting out as private collections a good many artworks from them were housed eventually in the archives of the Company Museum or Library. Lady Impey (1749–1818), wife of the Chief Justice of the Supreme Court of Calcutta, employed Indian artists to make depictions of birds, animals and plants as early as the 1770s. Many of the subjects for these drawings came from her splendid garden and menagerie. Today, drawings from the Impey collection can be found in both private and public archives throughout Britain.

Other nations with interests in India and Southeast Asia included the Dutch. The Dutch East India Company took possession of Ceylon (Sri Lanka) in 1658, keeping control until 1798, when the country came under the rule of the British. Of all the Dutch Governors of Ceylon it was Joan Gideon Loten (1710–80) who took the greatest interest in natural history, serving from 1752 to 1757. The artist for most of Loten's collection of drawings from his time in Ceylon was Pieter de Bevere (1722–?), who joined the service of the Dutch East India Company in 1743 as an assistant

surveyor. De Bevere worked from dead animals and birds, using them as models for his drawings, and is also known to have referred to George Edwards's popular publication *A Natural History of Birds* (1743–51). The Loten collection is modest in comparison to Hardwicke's or Hodgson's and the artwork is not always as sophisticated. Nevertheless, the quality hints at a measure of Asian influence, and Sydney Parkinson, natural history artist on James Cook's *Endeavour* voyage (1768–71), found the art worthy of copying before he left England on the voyage.

Additional collections are by individuals with some artistic talent who made drawings of the flora and fauna of their Indian surroundings for their own delight and personal interest. Among them are Lady Mary Bentinck (?–1843), Margaret Cockburn (1829–1928), Colonel Frederick Ditmas (1811–76) and Olivia Tonge (1858–1949). Bentinck, wife of the Governor General of India from 1817 to 1835 painted over sixty drawings of Himalayan birds in 1833. Cockburn was born in India and lived her entire life there. One of her many pleasures was drawing the wild plants, birds and insects of her surroundings. She also collected many specimens which have now become part of the collections in the Natural History Museum. Ditmas served in the Royal (Madras) Engineers between 1826 and 1850. He produced a small volume of drawings of birds, reptiles and insects which are thought to have been a gift to his wife. Tonge produced 16 delightful sketchbooks full of beautiful watercolours and humorous comments. The drawings are of the flora, fauna, places and objects bought or seen in the local markets during her travels in India from 1908 to 1913. They reflect her own experiences and observations and are annotated with interesting facts and personal memories.

Drawing was an important method of registering one's observations in a time before the invention of cameras, as well as being a visual recording of the natural world for the study of science. The Indian drawing collections at the Natural History Museum are testimony to the wonderful diversity of Indian natural history – the magnificent flora of the different regions and the variety of animals, birds and insects that populate the country. Study of these collections can advance our understanding of the natural sciences and add to a more complete and rounded knowledge of the relationship between India and Britain, between science and art and between the many layers of cultural and economic exchange that took place over the past 250 years.

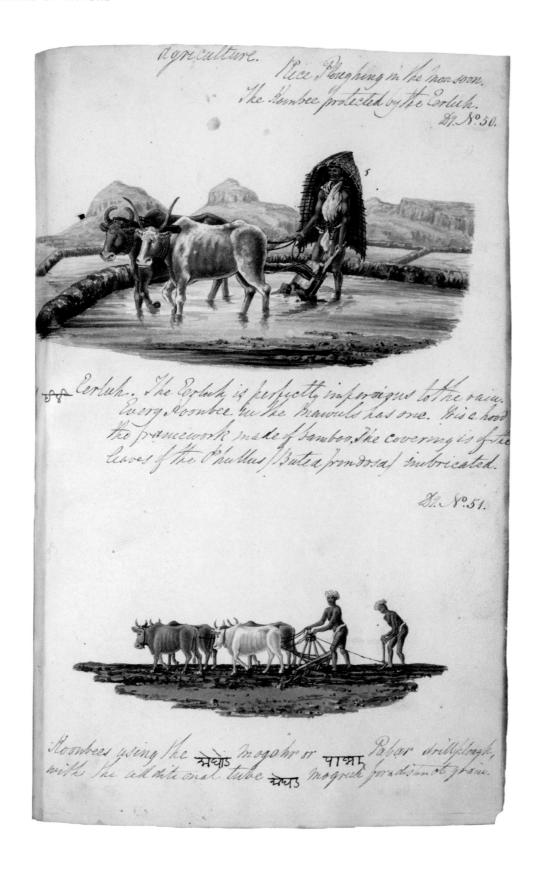

Agriculture.

Rice Ploughing in the monsoon.
The Koombee protected by the Erluh.
Dr. No. 50.

Erluh. The Erluh is perfectly impervious to the rain.
Every Koonbee in the Mawuls has one. It is a hood
the framework made of bamboo. The covering is of the
leaves of the Phullus (Butea frondosa) imbricated.

Dr. No. 51.

Koonbees using the ओघोड Mogohr or पाभर Pabar drill plough,
with the additional tube ओघप Mogreh for distinct grain.

Rice ploughing

These wonderful sketches are important records of agricultural practices of the 1820s in the Deccan region of southern India. The figure ploughing the rice field is protected from the monsoon rains by a covering called an eerluh. It is made from a bamboo frame and covered with leaves. The image in the lower half is of a drill plough.

Fidlor/Sykes Collection
Watercolour
1825–30
320 x 200 mm

Winnowing grain

These drawings describe two processes of extracting grain. The upper illustration demonstrates the treading of grain which is then followed by winnowing, called oopun. The second process is carried out in the kulleh or farmyard.

Fidlor/Sykes Collection
Watercolour
1825–30
320 x 205 mm

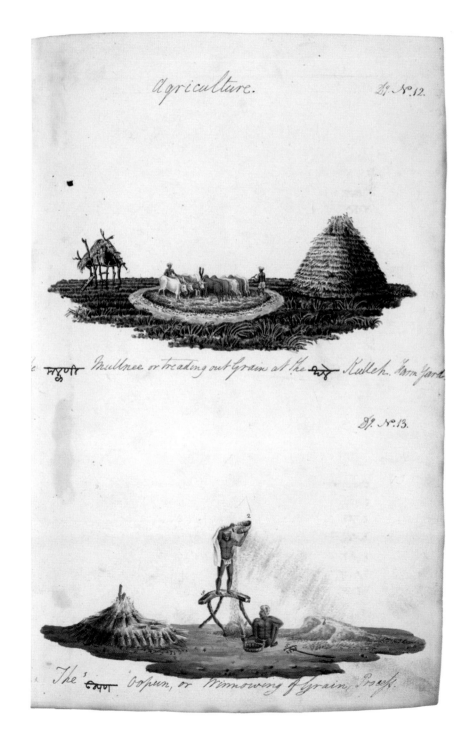

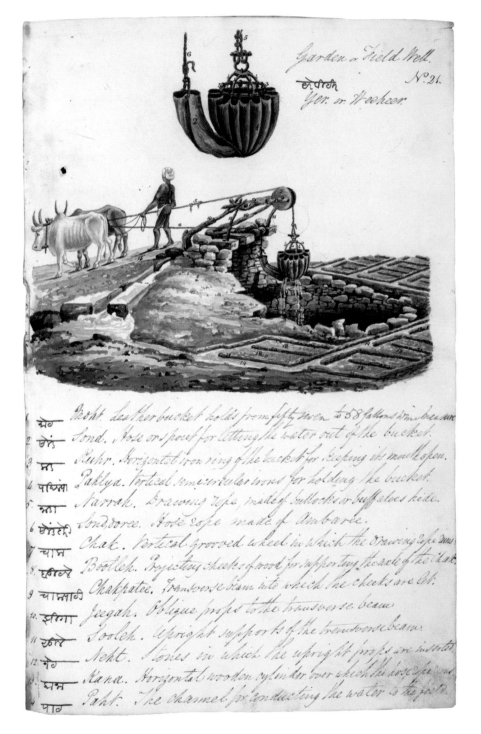

Garden or field well

Sykes noted that this was the most common method of irrigation in the districts he visited. In which two bullocks attached to a bucket 'pull down the inclined plane, discharge the water, and readily walk backwards up the plane'. Conducting an experiment he calculated the quantity of water brought up within a day and concluded that it far exceeded that which Europeans extracted.

Fidlor/Sykes Collection
Watercolour
1825–30
320 x 205 mm

British Embassy

The Residency at Kathmandu stood in grounds of some fifty acres and included a church, zoo and aviary. It was here that Hodgson spent almost twenty-five years. He was first an assistant, then acting and finally Resident Minister in the Nepalese capital. The pencil and ink sketch was made by Hodgson's brother, William.

W E Hodgson/Hodgson Collection
Ink
c. 1833
240 x 345 mm

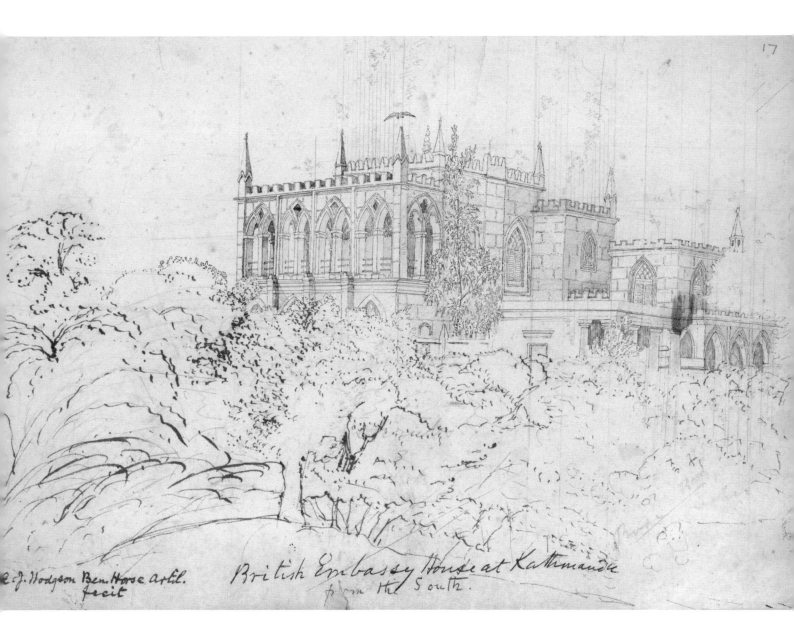

17

C. J. Hodgson Ben. Horse Artil.
fecit

British Embassy House at Kathmandu
from the South.

Brianstone House in Darjeeling

Hodgson named his four-bedroomed house in Darjeeling after himself. He spent thirteen years in the house from 1845 to 1858. His employees from Nepal together with some of his artists also moved there with him.

Mrs Gordon/Hodgson Collection
Watercolour
c. 1850
250 x 345 mm

Ancient powder horns

During her travels in India from 1908 to 1913 Olivia Tonge produced a beautiful collection of watercolour drawings. She drew the flora and fauna of the country, the places she visited and the objects she bought or saw in the local markets.

Tonge
Watercolour
c. 1910–12
180 x 258 mm

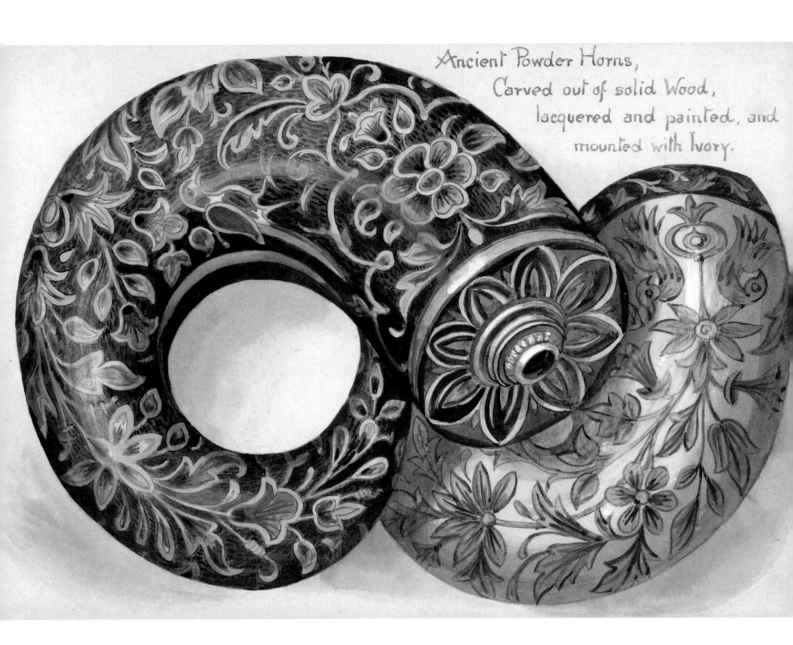

Ancient Powder Horns,
Carved out of solid Wood,
lacquered and painted, and
mounted with Ivory.

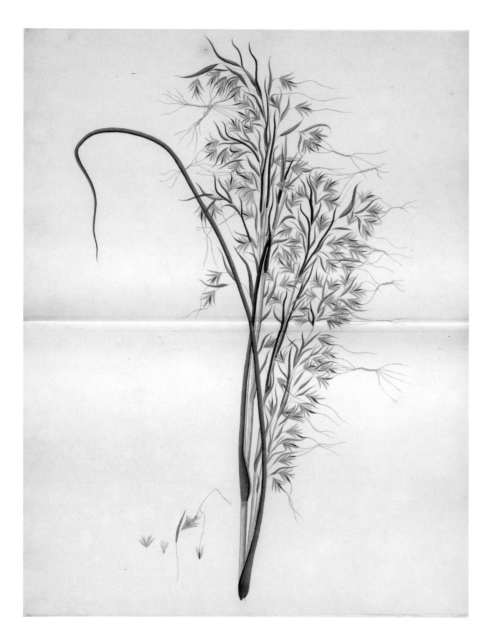

Themeda sp., grass

Grasses are one of the most successful plants and are found across the world in most open habitats. There are about 900 species of grass in India. Unfortunately this species has not yet been identified.

Kerr Collection
Watercolour
c. 1770s
690 x 528 mm

Carissa carandas, karonda

The drawings commissioned by Kerr represent good early botanical illustrations in the scientific style, some of the first to be made in India. The carissa is grown as an economic plant for its fruit.

Kerr Collection
Watercolour
c. 1770s
528 x 360 mm

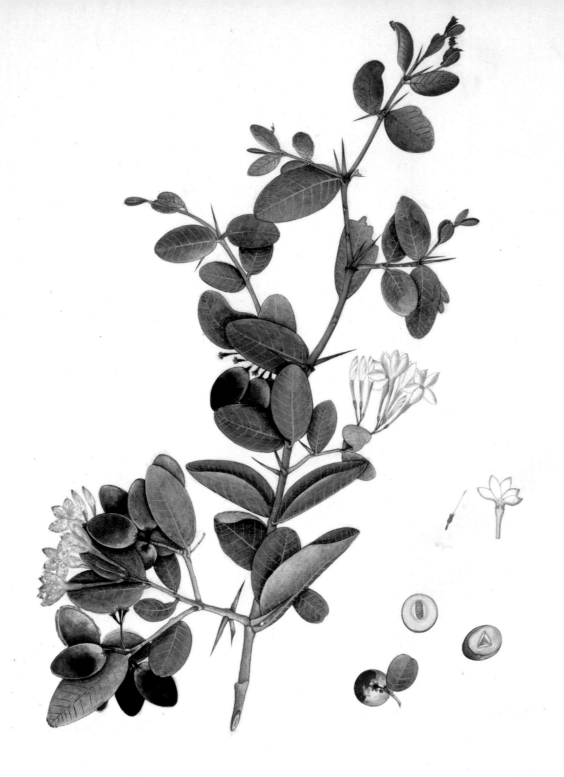

كروندا Kurrounda.- Currinda Beng:

Carissa Carandas

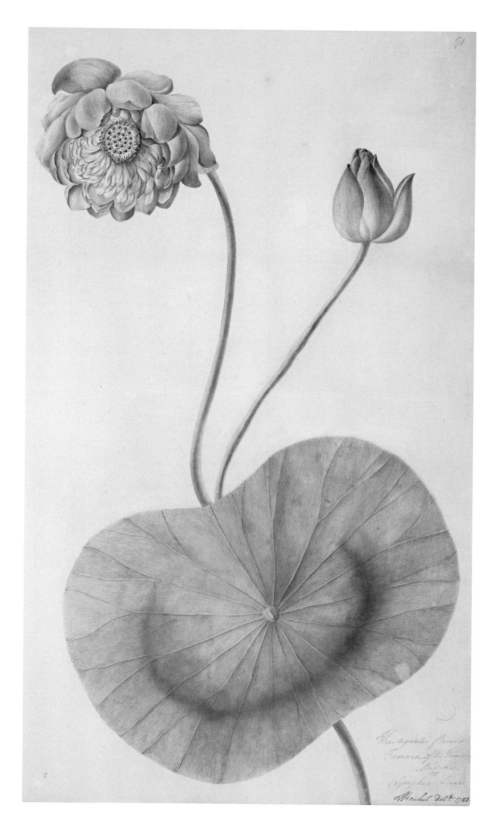

Nymphaea lotus, tiger lotus

Joseph Reichel was a civil draughtsman based in Madras from 1783 to 1791. Pursuing his interest in natural history he made some especially fine botanical drawings – the tiger lotus being a good example.

Reichel
Watercolour
1788
526 x 358 mm

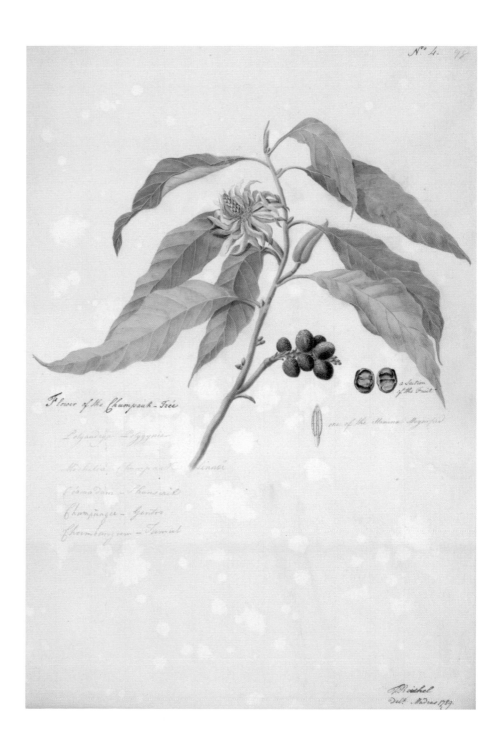

Magnolia champaca, champak
tree

This unusual looking magnolia is a large
evergreen tree with fragrant yellow
flowers. It is cultivated for its timber
and for producing an essential oil used
in making perfume.

Reichel
Watercolour
1789
508 x 352 mm

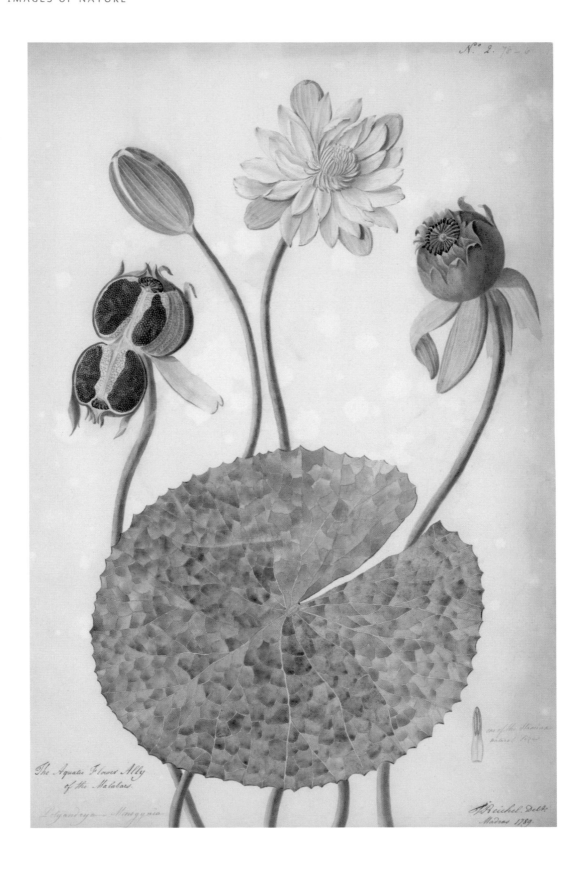

Nymphaea lotus, tiger lotus

This water lily was introduced to India from ancient Egypt. It is a night bloomer with beautiful white scented flowers. These flowers are often used as religious offerings.

Reichel
Watercolour
1789
525 x 353 mm

Typhonium venosum, arum

Like many members of the Araceae family this aroid produces a potent and unpleasant odour to attract pollinators which are usually carrion flies.

Hardwicke Collection
Watercolour
1796
502 x 338 mm

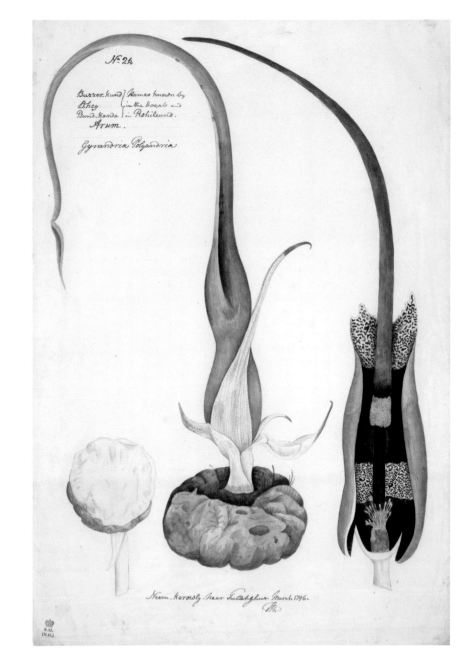

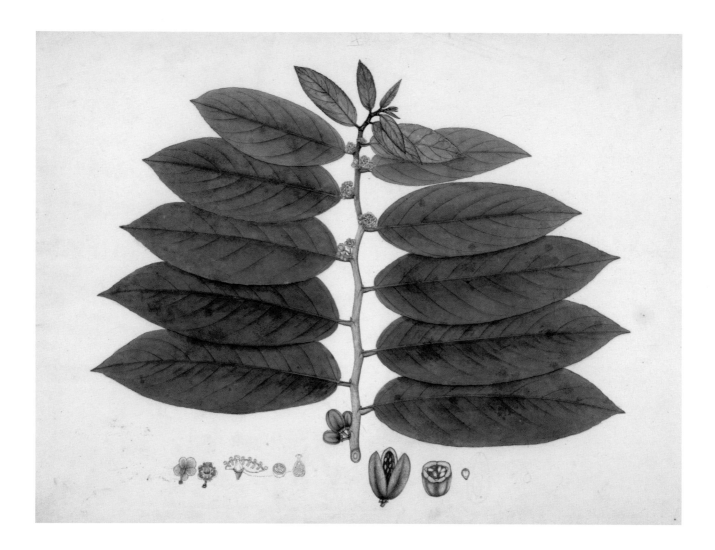

Guidonia tomentosa

This plant is native to India and like many of the plants drawn
for Wallich it appears in *Flora Indica* (1820) in which it was
first described.

Wallich Collection
Watercolour and ink
1817–32
344 x 482 mm

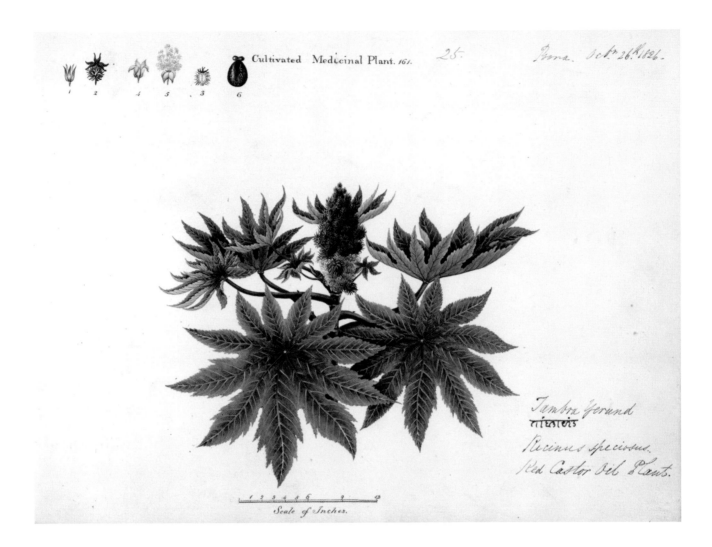

Ricinus communis, red castor oil

Much of Sykes's report of the population and natural history of the
Deccan plateau was dedicated to economic and medicinal plants,
both cultivated and wild. Today India is the largest producer of castor
oil which is extracted from the seed of the plant depicted here.

Fidlor/Sykes Collection
Watercolour
1826
230 x 310 mm

Citrullus colocynthis, bitter cucumber

Described as a wild medicinal plant by Sykes this bitter cucumber
is eaten as a vegetable and used as a laxative, to treat oedema
and amenorrhoea.

Fidlor/Sykes Collection
Watercolour
1828
261 x 370 mm

Abies spectabilis, Himalayan fir

Situated between the northern plains and the Himalayas the
Saharunpor garden was ideal for growing plants from more
temperate regions of the world. A hill-station branch of the garden
at Mussoorie specialised in pines from Europe and the colder
regions of Asia. This particular specimen came from Nepal.

Saharunpor garden Collection
Watercolour
1847
459 x 358 mm

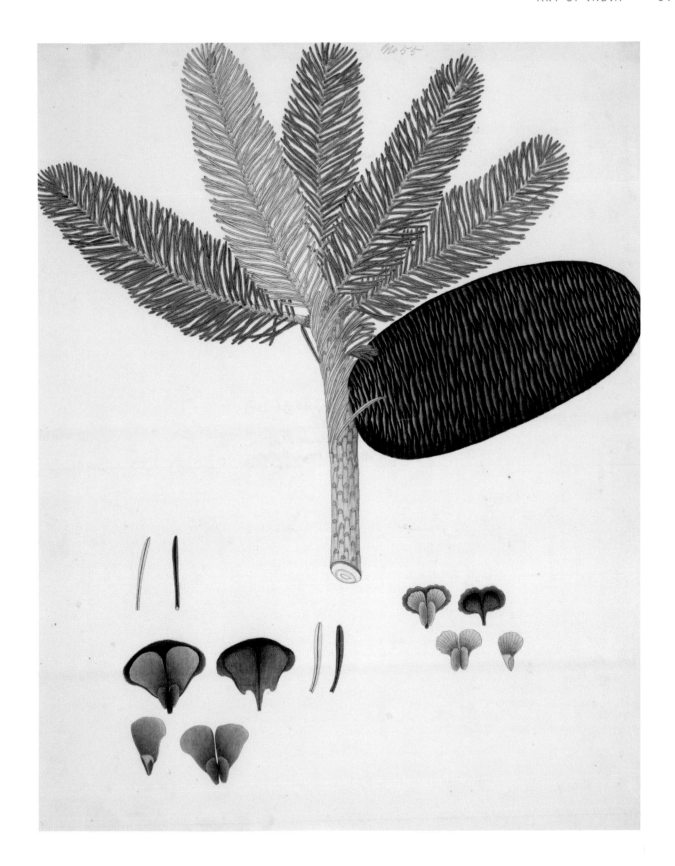

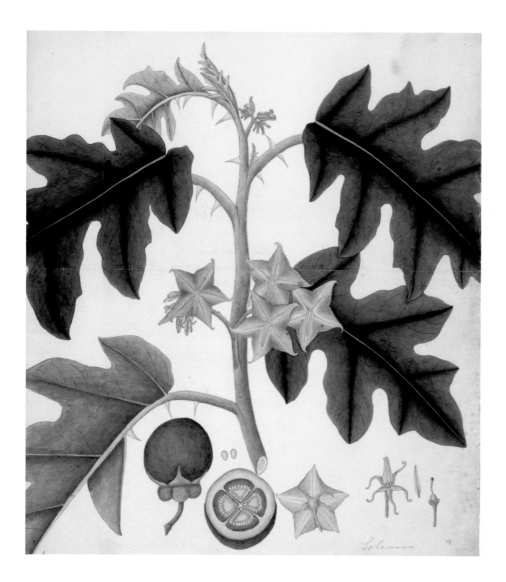

Solanum virginianum, nightshade

Most parts of this nightshade have medicinal uses. It is used
in the treatment of colds, coughs, asthma and rheumatism.

Saharunpor garden Collection
Watercolour
1848
455 x 390 mm

Dendrobium sp., orchid

Specialising in plants from northern India the Saharunpor garden sent
out parties of collectors each year to different parts of the Himalayan
mountains, along the Tibetan frontier and as far as Kashmir. Many
of the seeds and plants collected were sent to Europe where certain
plants such as orchids were highly sought after.

Saharunpor garden Collection
Watercolour
1848
480 x 370 mm

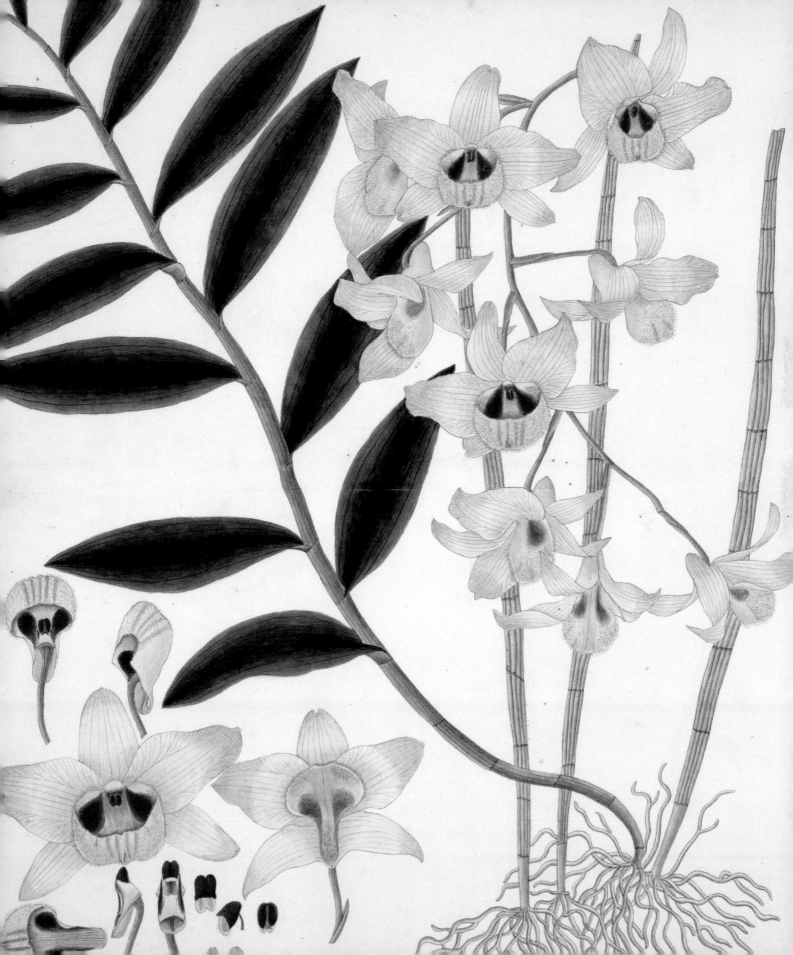

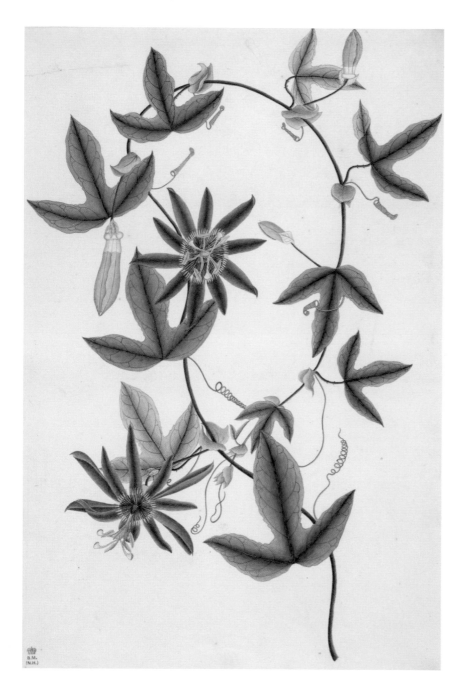

Passiflora kermesina, passiflora

Originally from Brazil this plant was introduced to the Saharunpor garden which at the time specialised in Himalayan plants.

Saharunpor garden Collection
Watercolour
c. 1850
463 x 304 mm

Theobroma cacao, cocoa
Myristica fragrans, nutmeg
Syzygium aromaticum, cloves

Nutmeg and clove both originate from the Moluccas or Spice Islands. Similar to the cocoa plant they were highly sought after by Europeans from the sixteenth century and used in flavouring foods and for medicinal purposes.

Cockburn
Watercolour
1858
260 x 205 mm

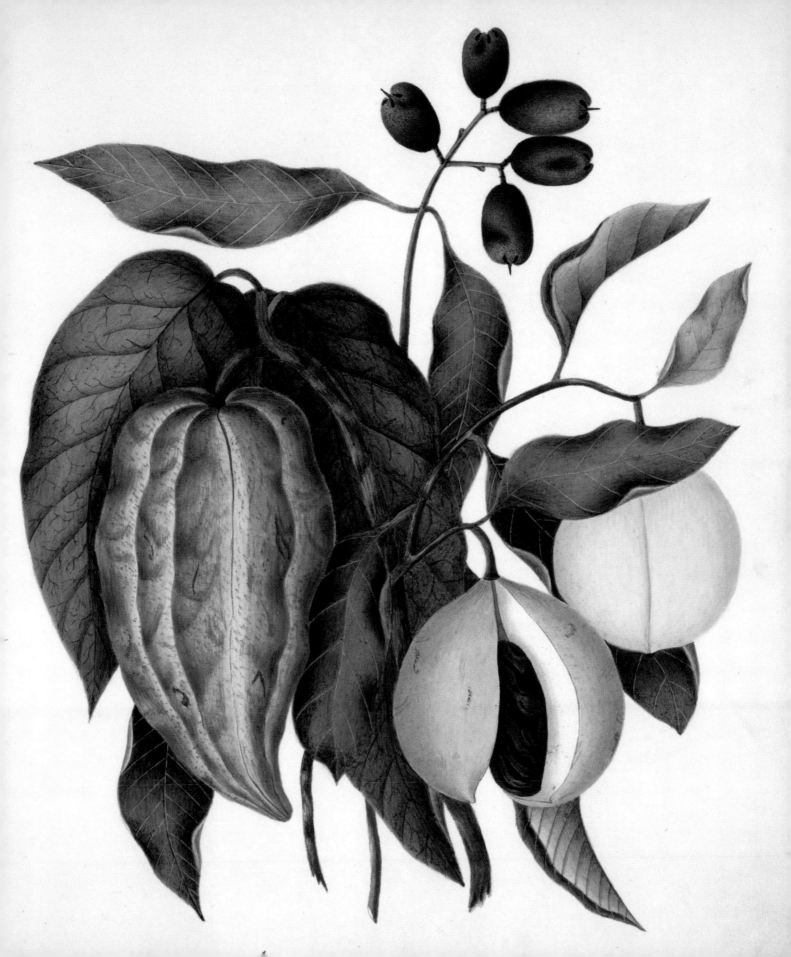

Ruellia.

Strobilanthas This blue shrub blossoms only once
every 12 years.

Strobilanthes kunthiana,
neelakurinji

The magnificent blue of the flowers of
this plant gives the name to the Nilgiri
Hills (Blue Mountains) in Tamil Nadu,
southern India. It grew in abundance
when Cockburn lived there and painted
it. The plant flowers only once every
twelve years.

Cockburn
Watercolour
1862
260 x 205 mm

Datura metel, angel's trumpet/
devil's trumpet

The common names for this plant
describe its beauty and its potential
danger. All parts of the plant are highly
toxic and if consumed could be fatal.

Indian miscellaneous Collection
Watercolour
c. 1820
448 x 363 mm

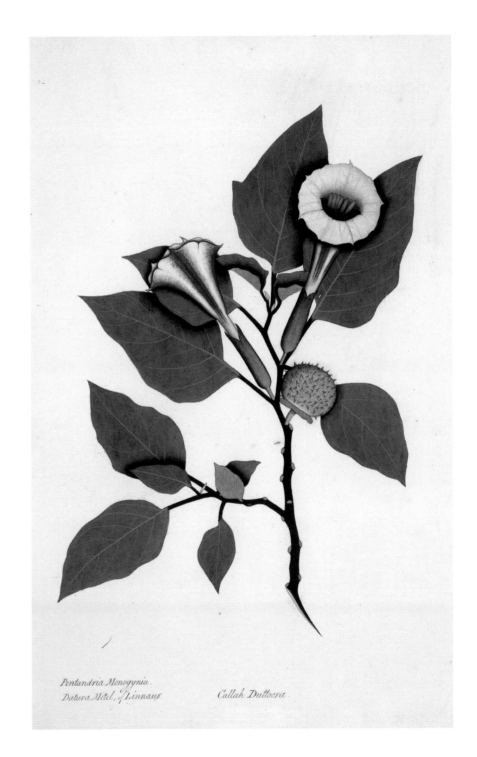

Pentandria Monogynia.
Datura Metel, of Linnaus *Callah Duttoora.*

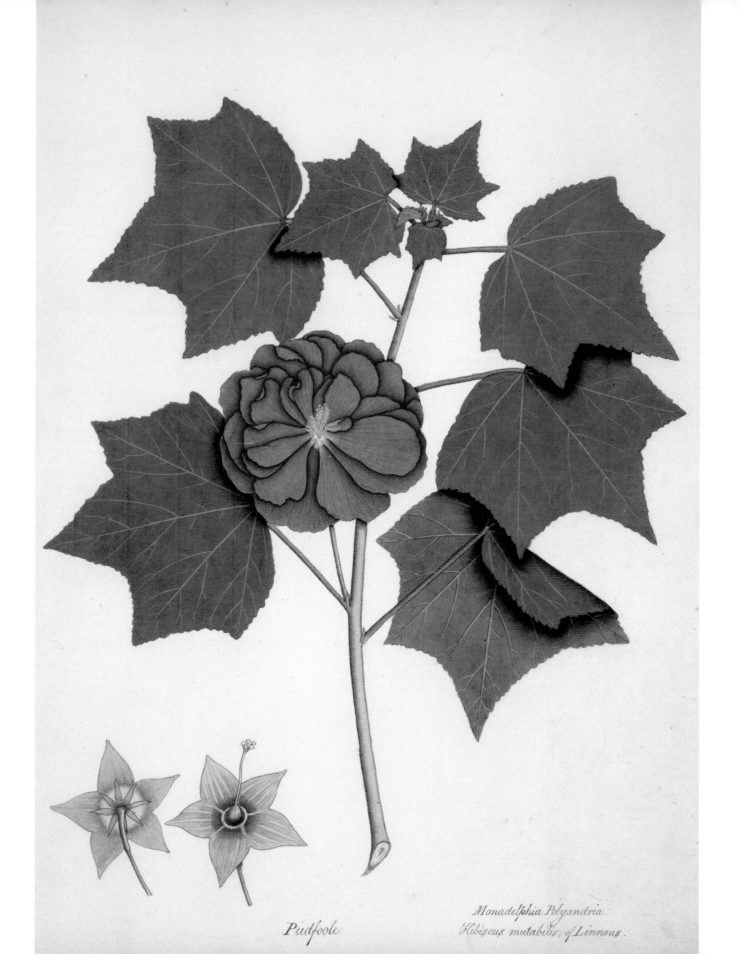

Pudfoole.

Monadelphia Polyandria.

Hibiscus mutabilis, of Linnæus.

Hibiscus mutabilis, cotton rosemallow

The flower of this splendid hibiscus changes colour through the course of the day, starting as white in the morning and turning pink and through to red by the evening.

Indian miscellaneous Collection
Watercolour
c. 1820
497 x 347 mm

Hedychium densiflorum, ginger lily

After his retirement Royle published *Illustrations of the Botany of the Himalayan Mountains* (1833–40). *Hedychium* does not appear in the volume of plates but Royle writes that several species of it were common in Nepal and the Sylhet Mountains and could be found as high as 7,000 feet.

Royle Collection
Watercolour and pencil
c. 1830
506 x 329 mm

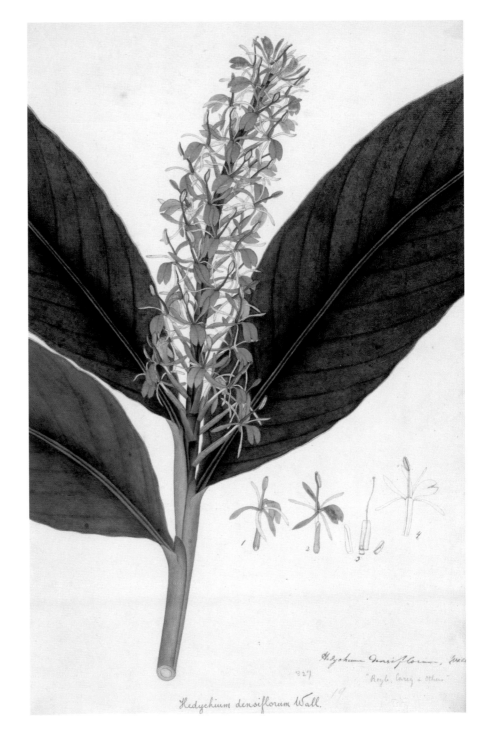

Hedychium densiflorum Wall.

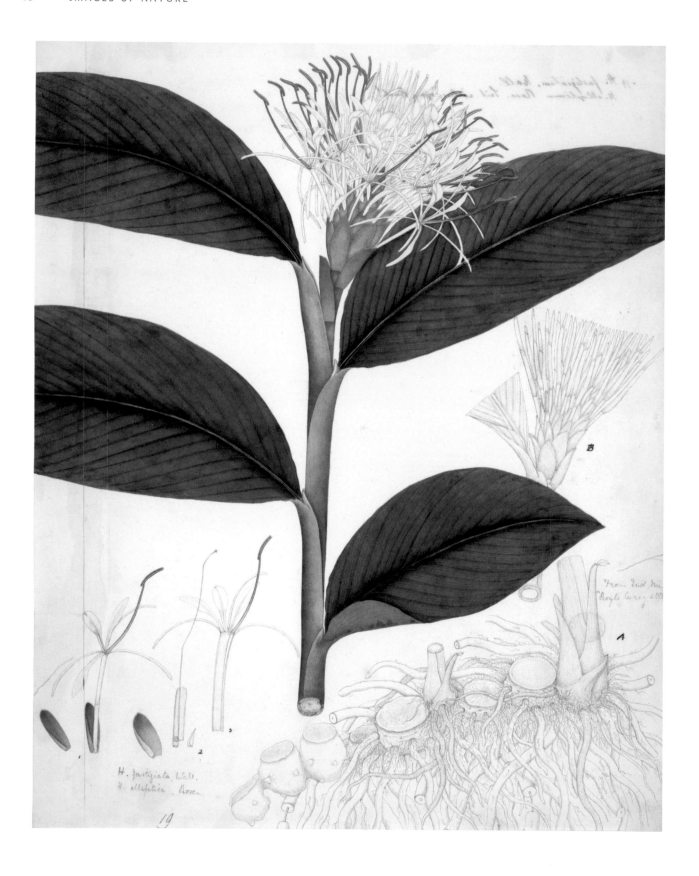

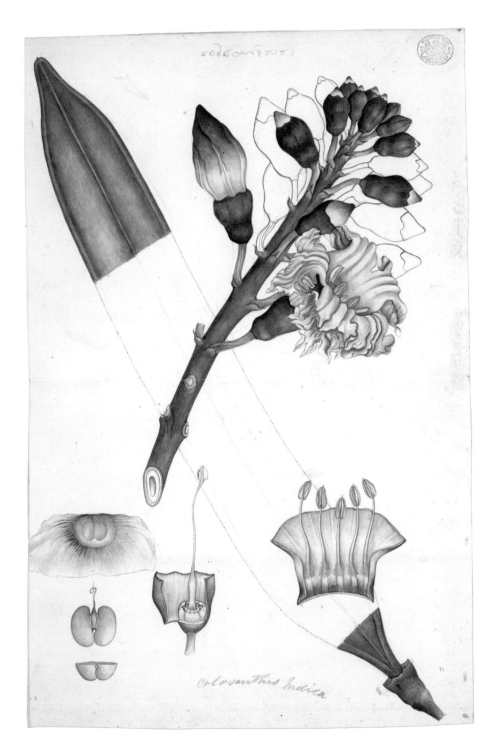

Hedychium ellipticum, shaving brush ginger

John Forbes Royle was in charge of the Saharunpore gardens which grew many plants from the Himalayas. The *Hedychium* is one from that region and was probably collected by Royle on one of his botanical expeditions.

Royle Collection
Watercolour
c. 1830
498 x 400 mm

Oroxylum indicum, Indian trumpet

This tree is a night bloomer and is pollinated by bats. The large pods are eaten as a food and the seed and bark are both used in traditional medicine.

Wight Collection
Watercolour
c. 1825–30
440 x 285 mm

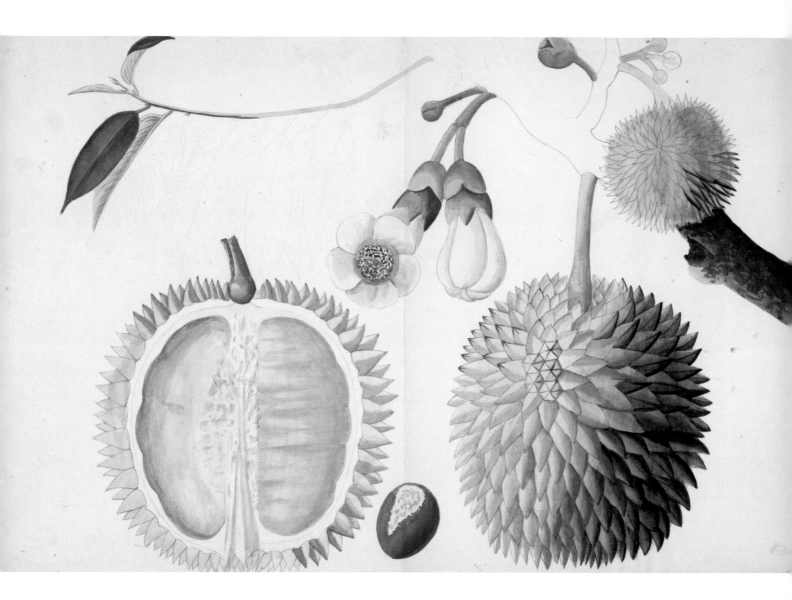

Artocarpus heterophyllus, jackfruit

The jackfruit is native to India and bears large, heavy fruits that are related to the mulberry. The plant is grown throughout Southeast Asia and used in different regional cuisines.

Wight Collection
Watercolour
c. 1825–30
285 x 440 mm

Coccinia sp. and Ipomoea pes-caprae, railroad vine

This work was prepared by a Portuguese-speaking Indian, Saluadores, who was assistant to the hospital at Anjengo. It is an early pharmacopoeia depicting medicinal plants with descriptions of their therapeutic properties.

Saluadores Collection
Watercolour
1750
420 x 280 mm

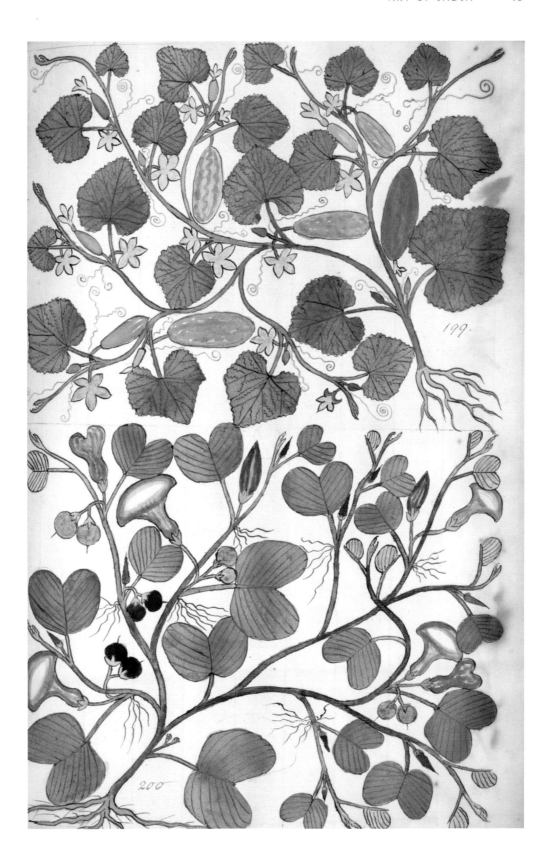

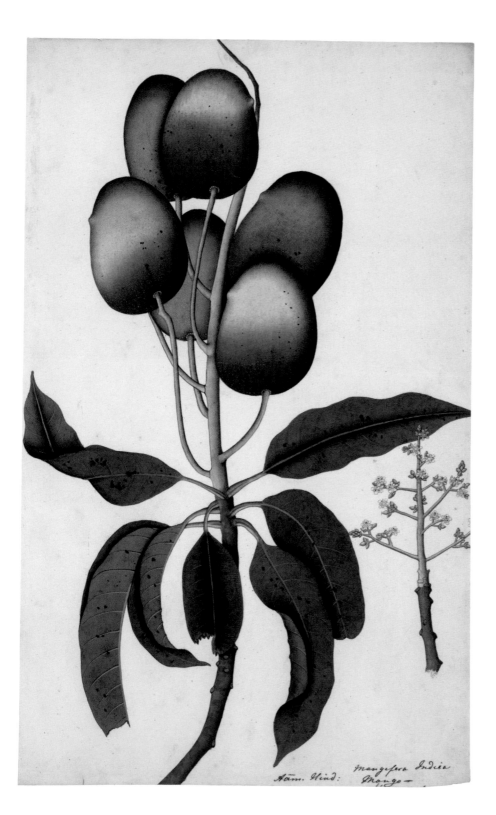

Mangifera indica, mango

Mango is the national fruit of India and grows wild as well as being cultivated. The leaves are used for religious and decorative purposes and the fruit not only tastes good but is considered to have medicinal properties.

Fleming Collection
Watercolour
c. 1805
484 x 293 mm

Ipomoea mauritiana, giant potato

This vine is a type of morning glory, which is naturalised in the subtropical regions in many parts of the world. It is cultivated for its large red-purple flowers.

Indian Drawing Collection
Watercolour
c. 1830
461 x 295 mm

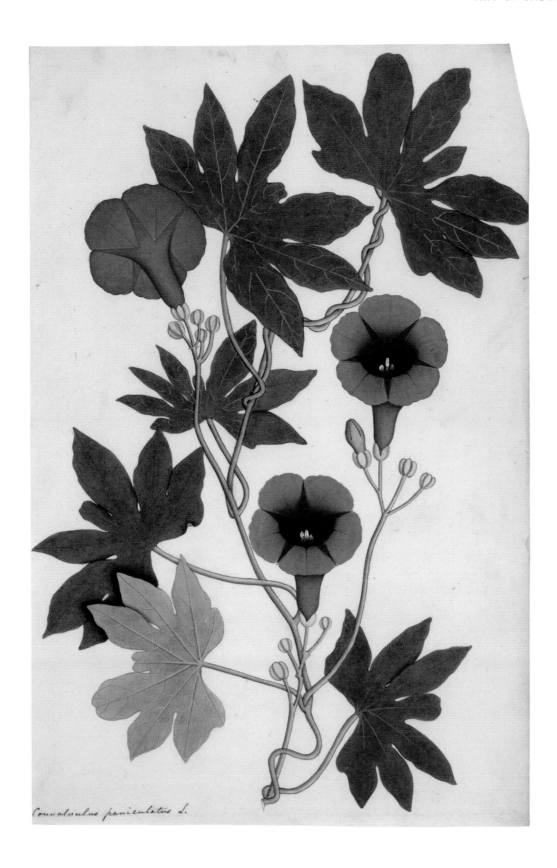

Convolvulus paniculatus L.

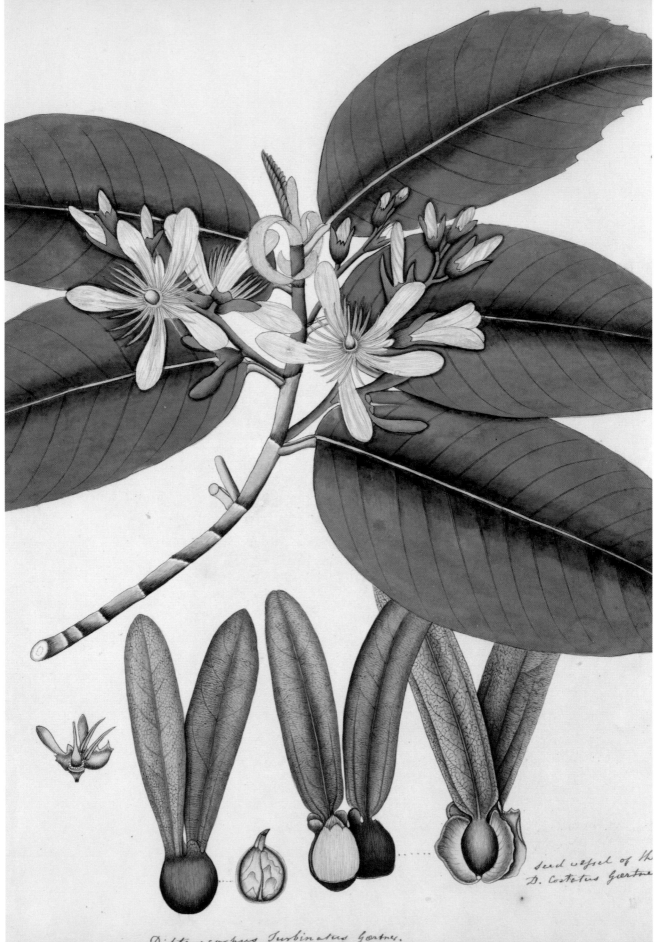

seed vessel of the
D. Costetus Gærtner

Dipterocarpus Turbinatus Gærtner.

Dipterocarpus turbinatus, wood oil tree

This plant is commercially exploited for its timber, which is used in the making of plywood. It appears as critically endangered on the International Union for Conservation of Nature (IUCN) red list of threatened plants.

Indian Drawing Collection
Watercolour
c. 1830
440 x 285 mm

Sonneratia caseolaris, mangrove apple

This tree grows in the mangrove forests along the coast of the Indian peninsula. The wood is used for boat building and construction. The fruit and leaves are eaten and used in traditional medicine.

Indian Drawing Collection
Watercolour
c. 1830
454 x 277 mm

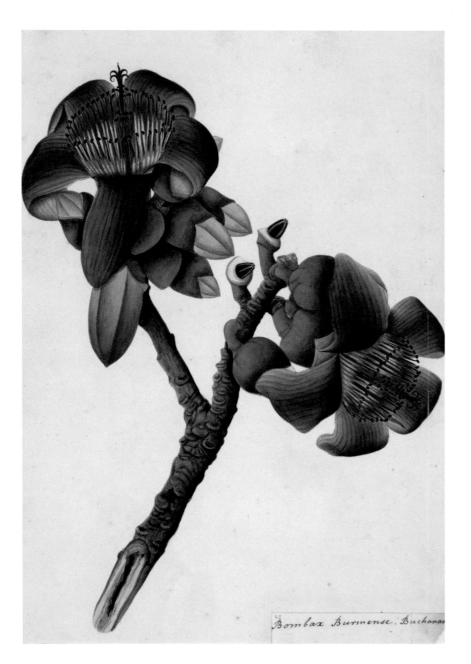

Bombax ceiba, cotton tree

The fruit and vivid red flowers attract a whole host of insects and birds who feed upon it and help to pollinate the plant.

Indian Drawing Collection
Watercolour
c. 1830
399 x 278 mm

Bombax ceiba, cotton tree

In spring this large tree has striking red flowers and is found throughout India. It is widely used in traditional medicine with every part of the plant used. It is also grown for commercial purposes as a fodder, fuel and fibre producing plant.

Fleming Collection
Watercolour
c. 1805
364 x 278 mm

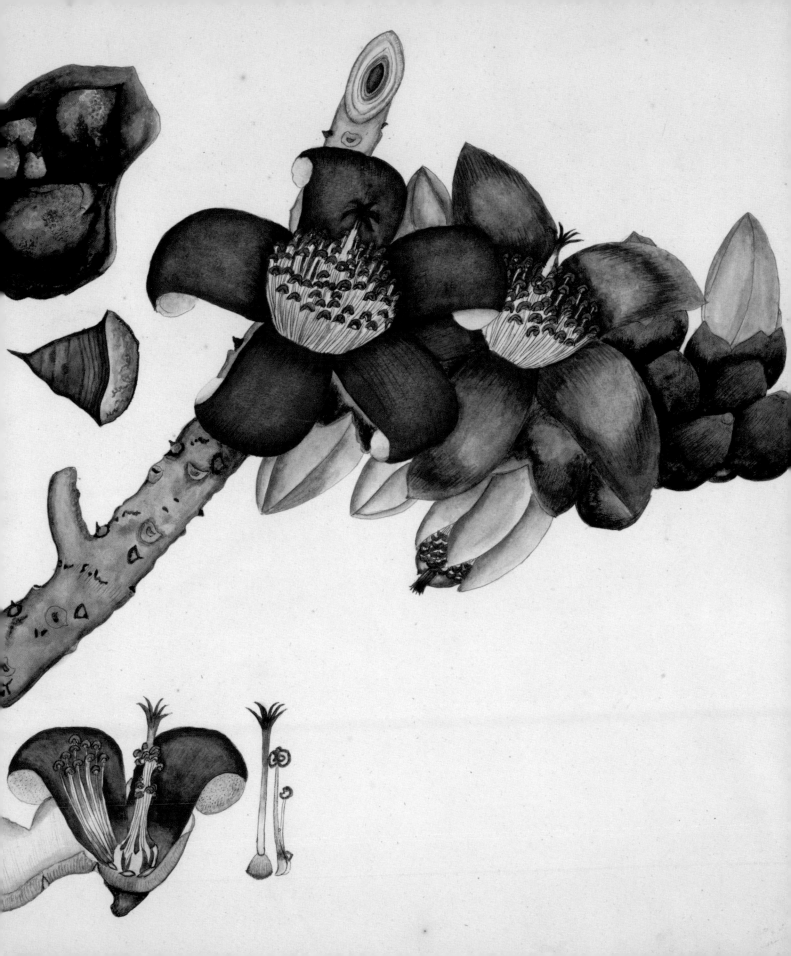

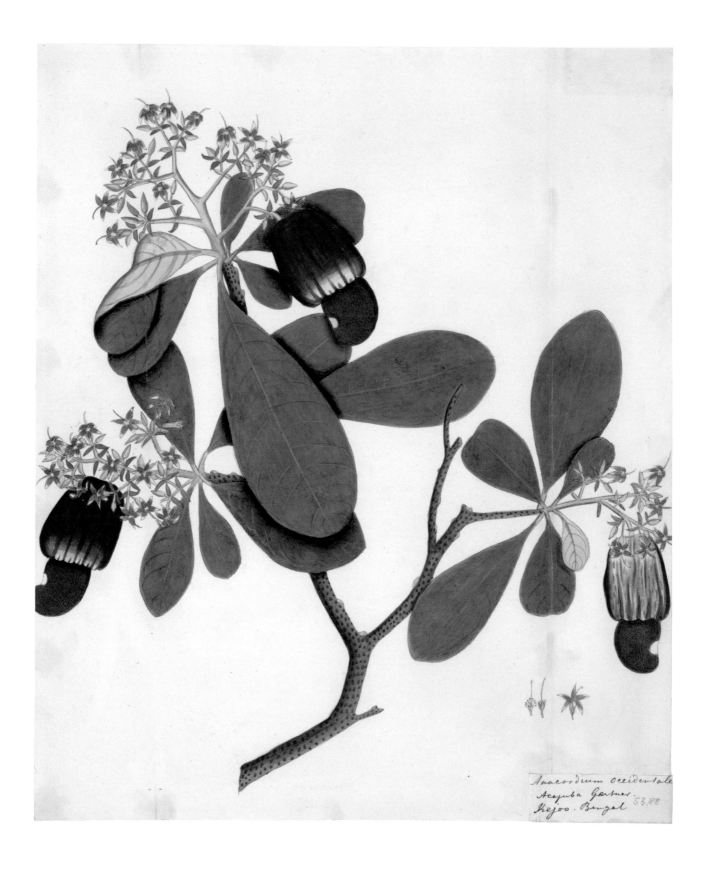

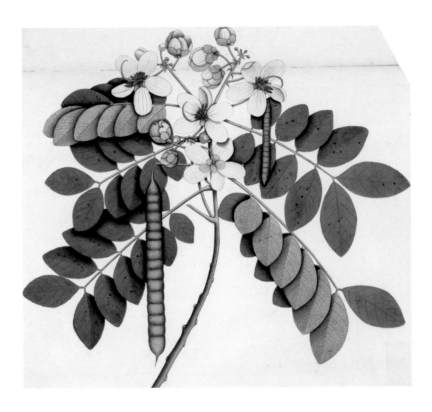

Anacardium occidentale, cashew

Cashew was introduced to India from South America by the
Portuguese in the sixteenth century. Since then India has become
the world's second largest producer of cashew nuts.

Fleming Collection
Watercolour
c. 1805
400 x 330 mm

Senna pallida, twin flowered cassia

Senna is a tropical plant originating from the New World. It is grown
for ornamental purposes but also has medicinal properties – the
leaves and pods are used mainly as a laxative.

Fleming Collection
Watercolour
c. 1805
325 x 351 mm

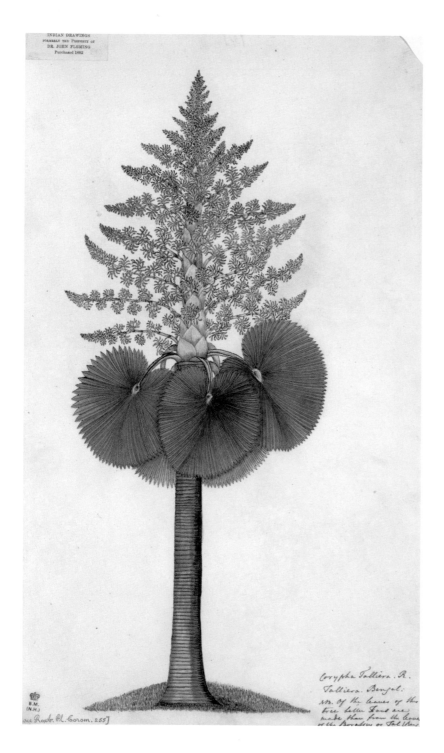

Corypha umbraculifera, talipot
palm

This palm is native to South India and
Sri Lanka. In Kerala the beautiful leaves
of this palm are used for thatching and
to make umbrellas.

Fleming Collection
Watercolour
c. 1805
470 x 272 mm

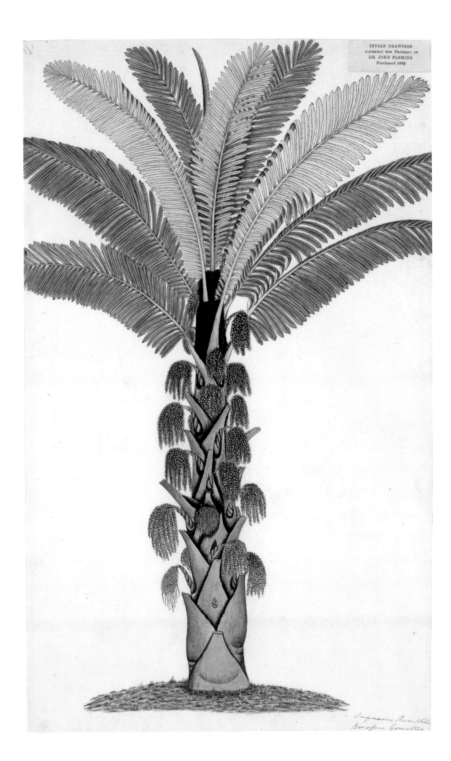

Arenga pinnata, sugar palm

Sap from this palm is harvested for commercial uses in Southeast Asia. The sap yields a sugar known in India as 'Gur' which is fermented into vinegar and wine.

Fleming Collection
Watercolour

c. 1805
466 x 275 mm

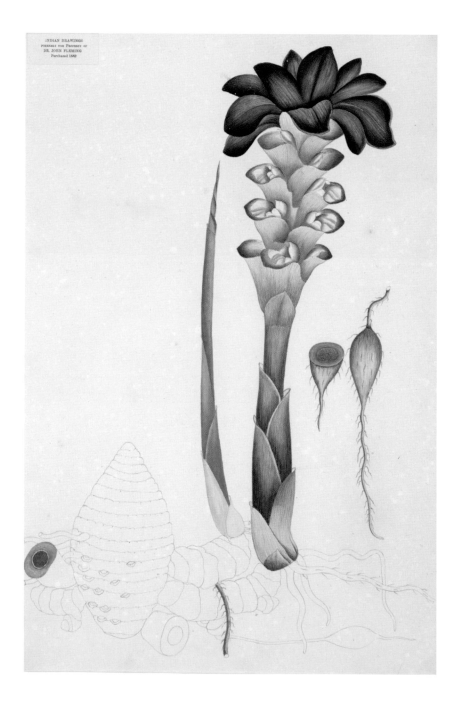

Curcuma xanthorrhiza, curcuma
Curcuma is a member of the ginger family and has numerous medicinal properties. It is mainly used as an anti-inflammatory and antibacterial.

Fleming Collection
Watercolour
c. 1805
495 x 320 mm

Bauhinia purpurea, purple camel's foot
Native across Southeast Asia, this small tree has attractive double-lobed leaves and striking pink flowers that are highly fragrant. The seeds form in long greenish-purple pods.

Fleming Collection
Watercolour
c. 1805
467 x 327 mm

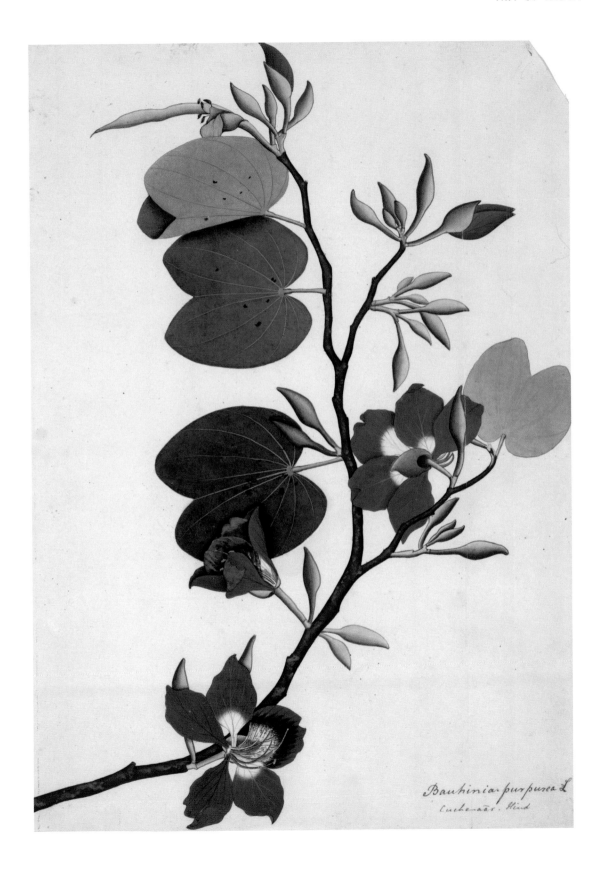

Bauhinia purpurea L.
Cachenaar. Hind.

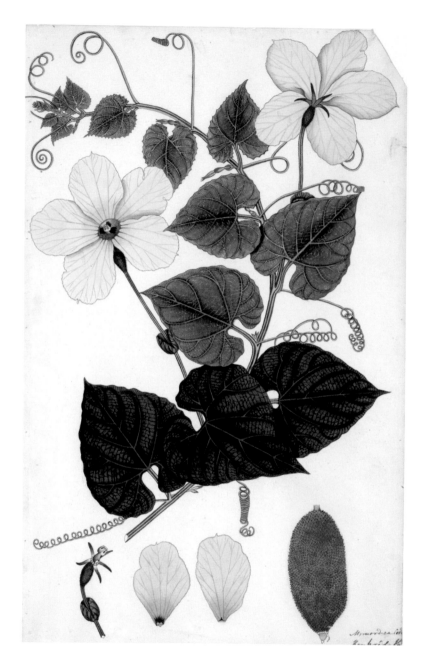

Momordica subangulata, wild
bitter gourd

This plant is found both wild and
cultivated across most of Southeast
Asia. The fruits and young shoots of this
climbing plant are eaten as a vegetable.

Fleming Collection
Watercolour
c. 1805
470 x 293 mm

Amorphophallus bulbifer,
devil's tongue

This species is native to northeast India.
The flower is usually 40 centimetres
long and the leaf can reach one metre
high. A new leaf will form each year but
many years may pass before a flower
appears.

Fleming Collection
Watercolour
c. 1805
459 x 284 mm

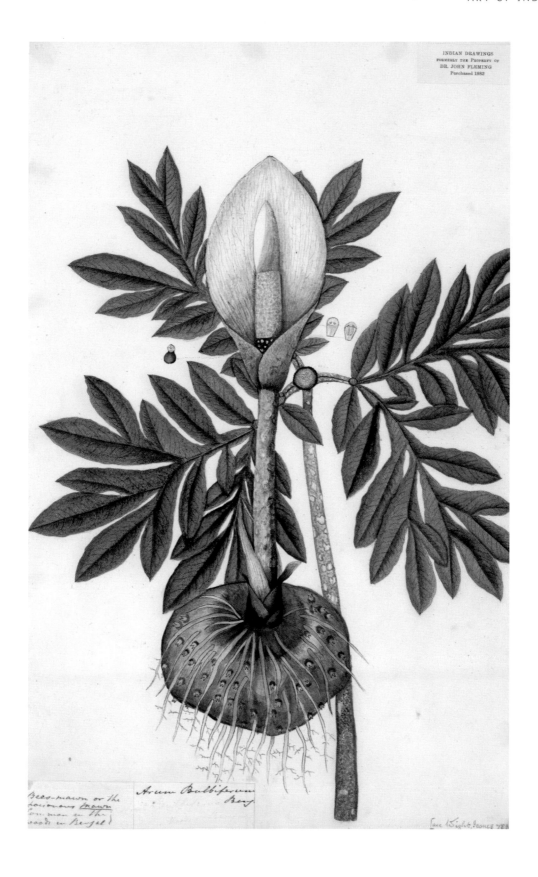

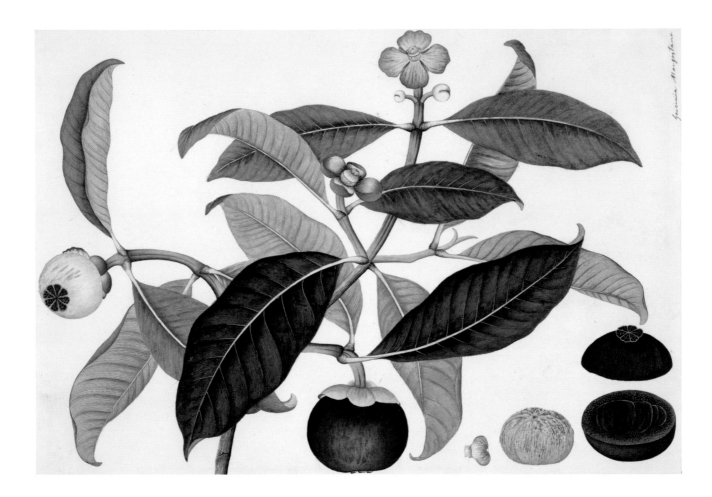

Garcinia mangostana, mangosteen

The soft, fragrant fruits of this plant are edible and encased in a hard
purple rind. This plant is native to Southeast Asia and is cultivated
throughout the Tropics.

Fleming Collection
Watercolour
c. 1805
330 x 477 mm

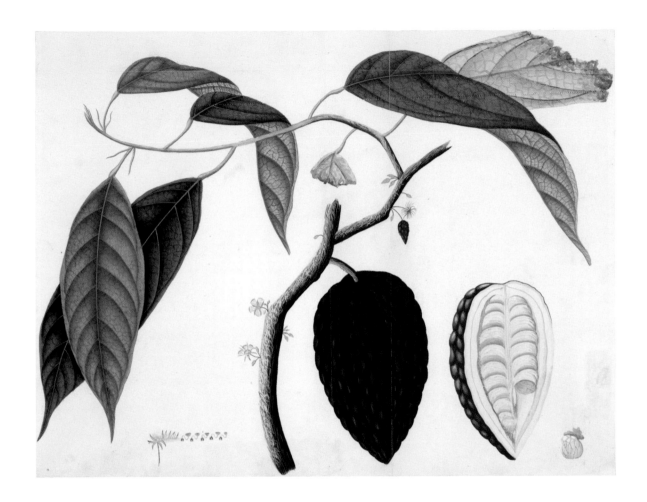

Theobroma cacao, COCOA

Cocoa was one of the earliest of plants to be domesticated. Originally from South America it is today grown in tropical regions across the world. India is one of the top twenty producers although it was not until the mid-twentieth century that it was grown as a cash crop.

Fleming Collection
Watercolour
c. 1805
357 x 467 mm

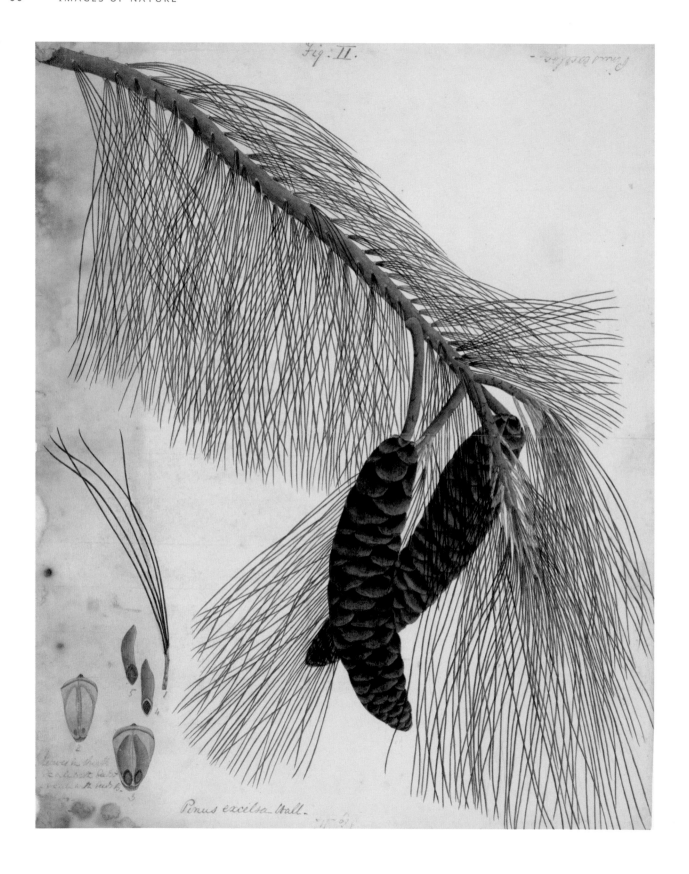

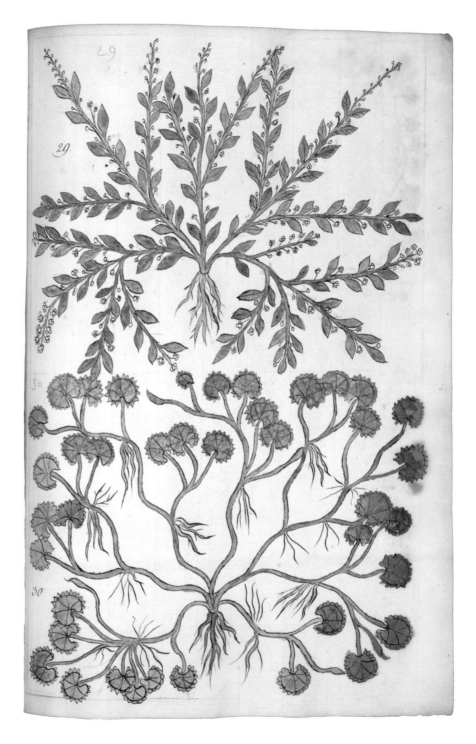

Pinus wallichiana, Pinus

This was drawn from a specimen growing in the hill-station branch of the garden at Mussoorie, some 213 metres up in the Himalayas.

Saharunpor garden Collection
Watercolour
c.1847
489 x 383 mm

Evolvulus alsinoides, dwarf morning-glory, *Centella asiatica*, Asian coin leaf

Evolvulus and *Centella* are both used in traditional medicines. *Evolvulus* is believed to improve brain functions such as memory and concentration.

Saluadores Collection
Watercolour
1750
420 x 280 mm

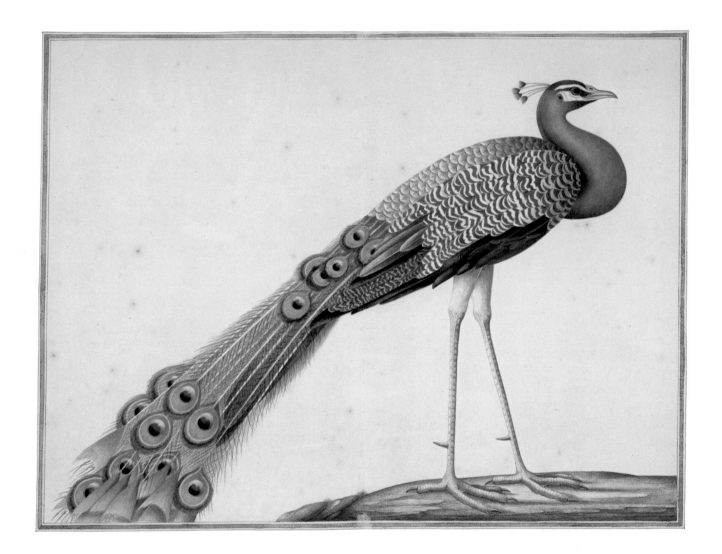

Pavo cristatus, Indian peafowl

'The most splendid of living birds' was Darwin's description of the
peahen. With a long history of cultural and religious significance in
India, the Indian peafowl was designated the national bird in 1963.

Bevere/Loten Collection
Watercolour
1752–57
385 x 498 mm

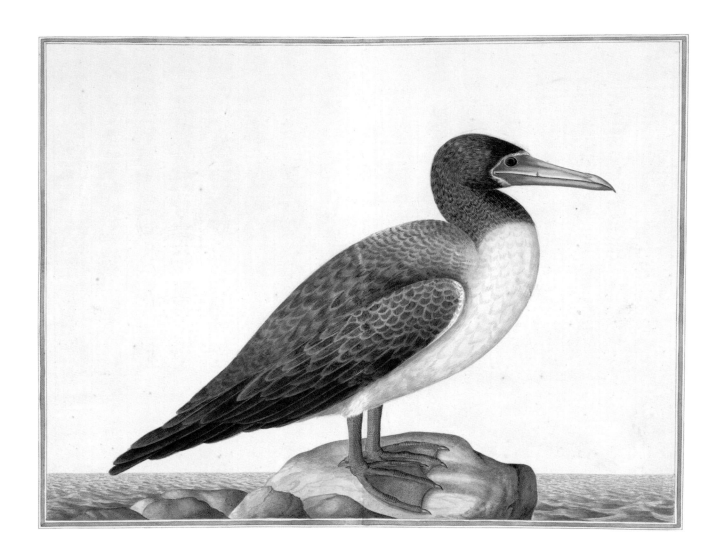

Sula dactylatra, masked booby (juvenile)

This bird was found in Colombo after a storm in 1755 and handwritten on the back of the drawing are the words 'fallen down at Colombo in Stormy weather 1755. The booby of Sloane less than its natural size.' The masked booby breeds on several Indian Ocean islands, but wanders occasionally into the seas off southern India and Sri Lanka.

Bevere/Loten Collection
Watercolour
1755
390 x 494 mm

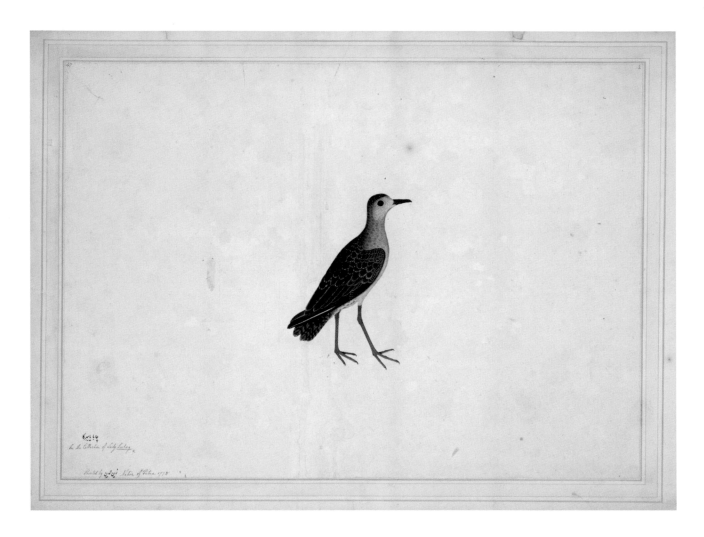

Philomachus pugnax, ruff

This bird appears to be a female ruff. The name comes from the breeding plumage of the males, which resembles a bold coloured ruff collar. This bird is a winter migrant to India.

Impey Collection
Watercolour
1778
510 x 713 mm

Ithaginus cruentus, blood pheasant

Blood pheasant is a small, unusual mountain pheasant that gets its common name from the red feathering on its chest, lending it a blood-stained appearance. This drawing was made from a specimen in the collection of Edward Gardner, the first British Resident of Kathmandu.

Hardwicke Collection
Watercolour
1818
360 x 419 mm

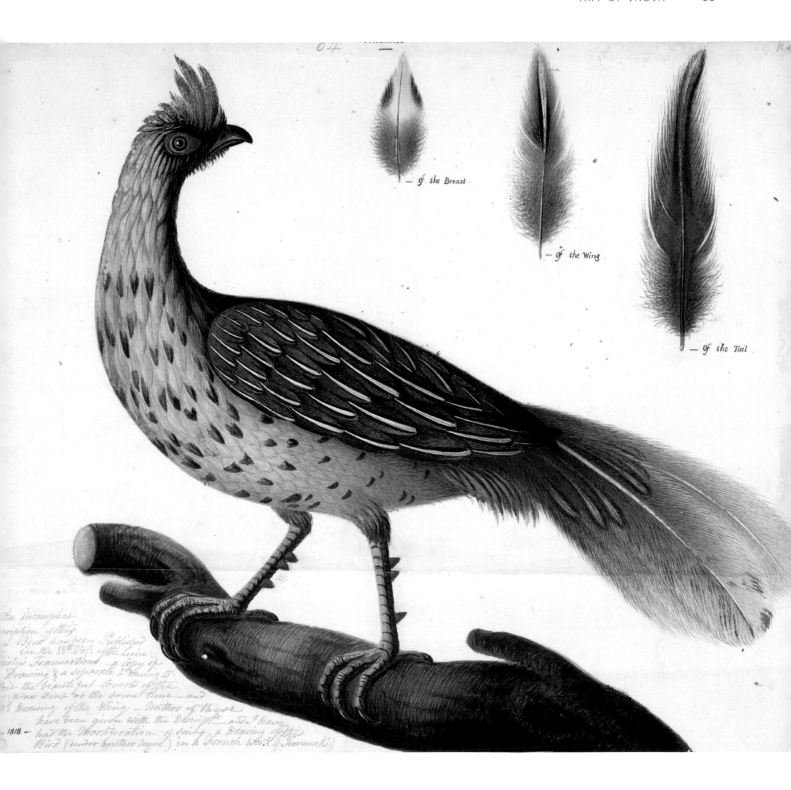

— of the Breast

— of the Wing

— of the Tail

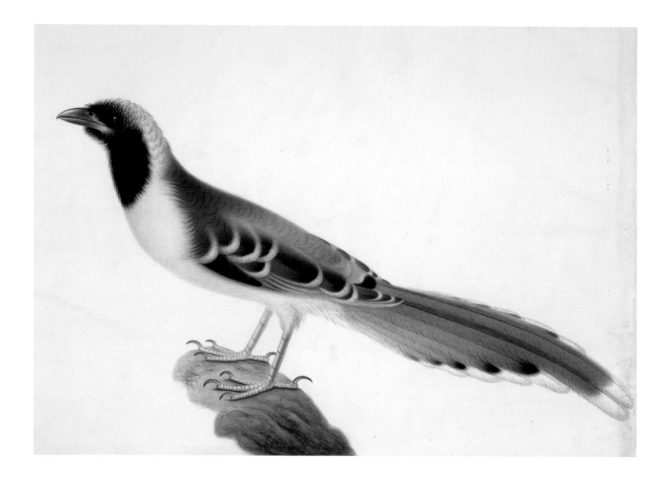

Urocissa erythrorhyncha, red-billed blue magpie

This elegant bird is a resident of the Himalayas and further east, into China and Thailand. It is also frequently depicted in Chinese art.

Hayes/Hardwicke Collection
Watercolour
1822
369 x 513 mm

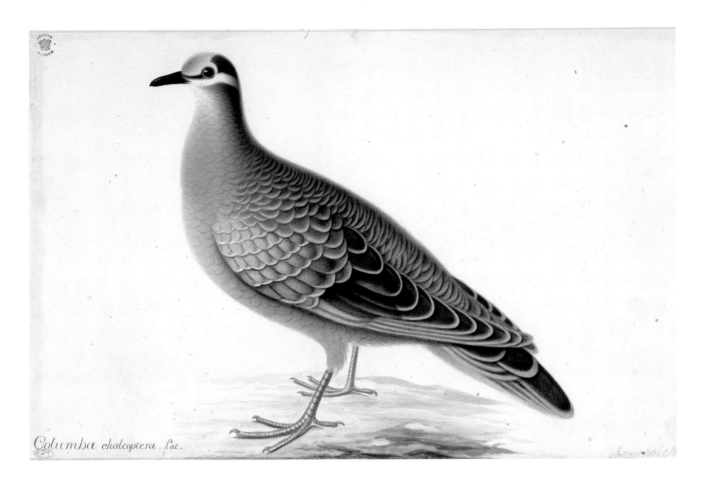

Columba chalcoptera. Lac.

Phaps chalcoptera, common bronzewing

Surprisingly, this striking pigeon is endemic to Australia. The bright iridescent yellow-gold, purple and green feathers on its wings, combined with a docile nature probably made it attractive for trading as a captive bird.

Hayes/Hardwicke Collection
Watercolour
1822
278 x 420 mm

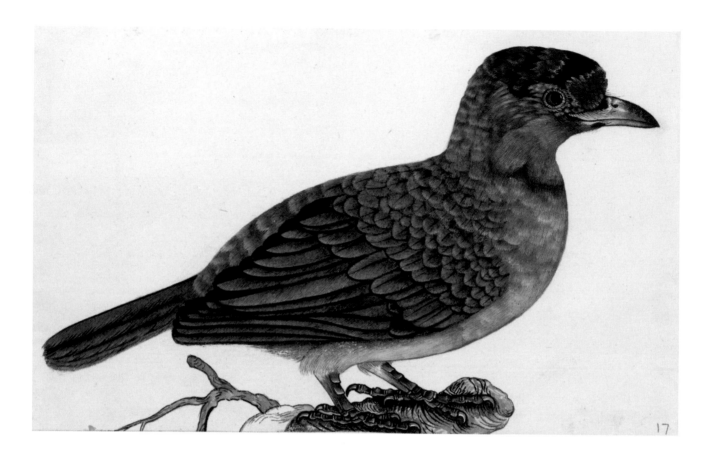

Megalaima asiatica, blue-throated barbet

The blue-throated barbet is a resident of the Himalayan foothills,
but it is also found in Bangladesh and west to Calcutta. Although the
posture is rather too upright, the bristles around the beak that give
barbets their common name are clearly visible.

Bentinck
Watercolour
1833
140 x 225 mm

Porphyrio porphyrio policocephalus, purple swamphen

Although the size of the legs and feet have been somewhat exaggerated, this is India's largest rail, about 50 centimetres long. It is found in the wetlands of India.

Hodgson Collection
Watercolour
c. 1840s
475 x 285 mm

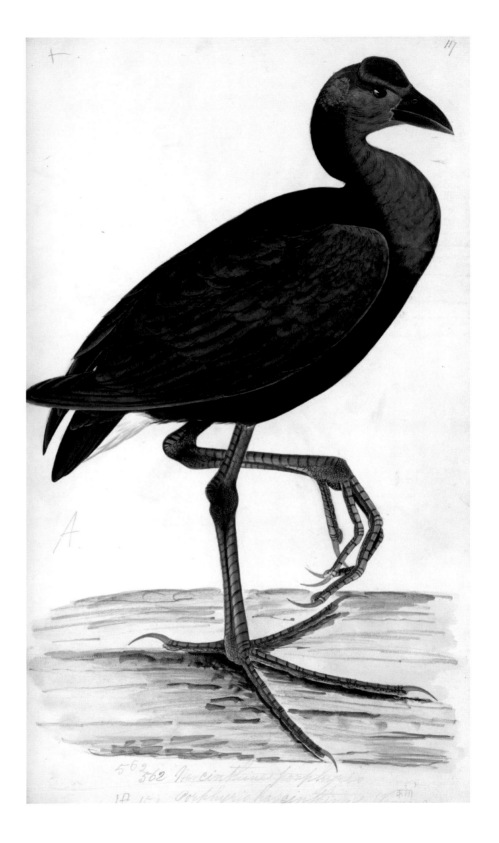

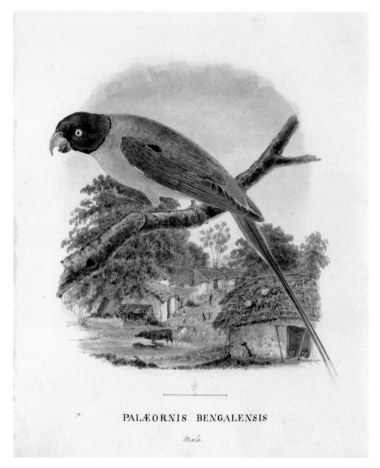

PALÆORNIS BENGALENSIS

Male

Psittacula cyanocephala, plum-headed parakeet

Plum-headed parakeet is endemic to the Indian subcontinent. The individual shown here is a male, the females have a grey head. The long relationship between parrots and people in India is hinted at by the village in the background and in the vignette figured at the end of the description written by Tickell.

Tickell
Watercolour
1848
224 x 180 mm

Mycteria leucocephala, painted
stork

This large and handsome stork is
a breeding resident of the Indian
peninsula and the Himalayas. In winter
it can be found in wider Southeast
Asia. Although still abundant, it is
now considered near threatened as
populations decline due to hunting,
drainage and pollution of its habitats.

Hodgson Collection
Watercolour
c. 1840s
475 x 285 mm

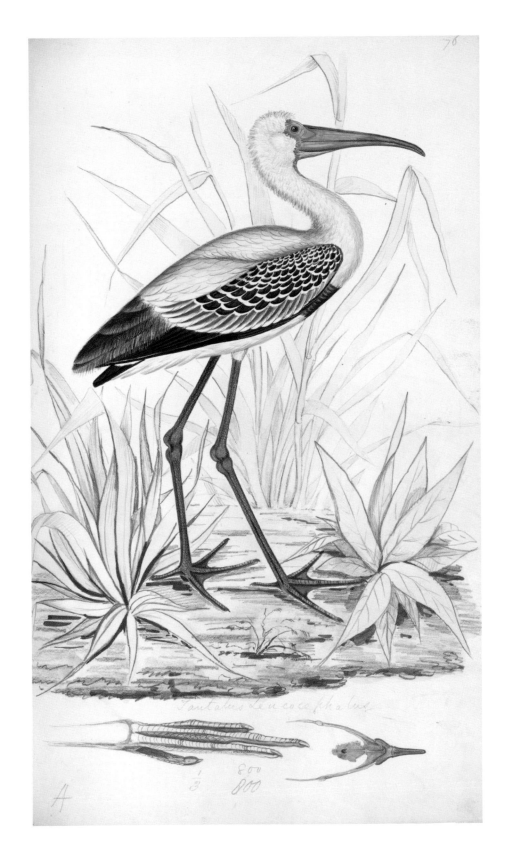

Aethopyga saturata, black-breasted sunbird

This is an unusual method of displaying a specimen. The sunbird has
been preserved and placed in the centre of a romantic Indian setting.

Hodgson Collection
Watercolour
c. 1850
225 x 305 mm

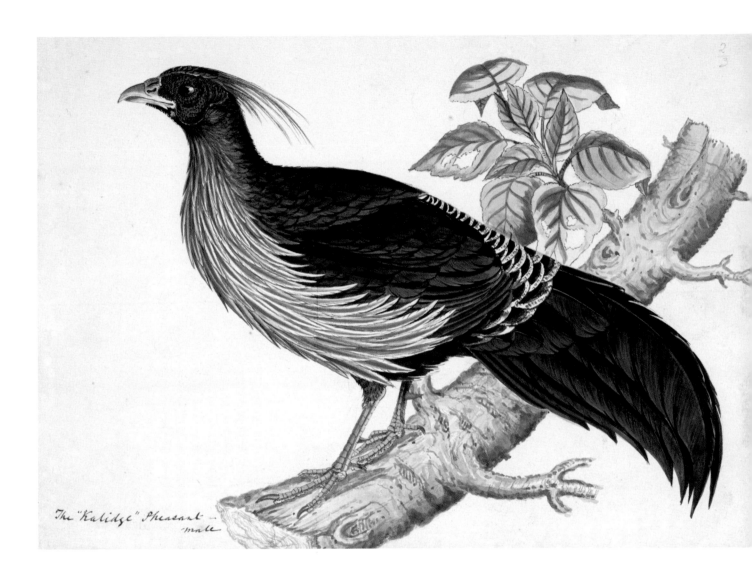

The "Kalidge" Pheasant — male

Lophura leucomelanos, kalij pheasant

The males of this striking pheasant can grow up to 75 centimetres long. They are easily kept in captivity and were popular in European menageries in the mid-nineteenth century.

Rajman Singh
Watercolour
1856–64
255 x 358 mm

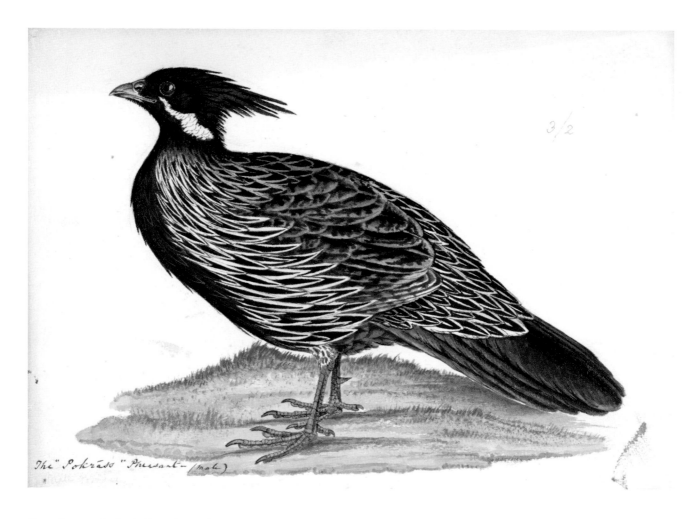

The "Pokrass" Pheasant – (male)

Pucrasia macrolopha, koklass pheasant

Koklass is a shy pheasant found in mountain forests. The name
koklass, or the older version pokrass, comes from its loud
territorial call.

Rajman Singh
Watercolour
1856–64
255 x 358 mm

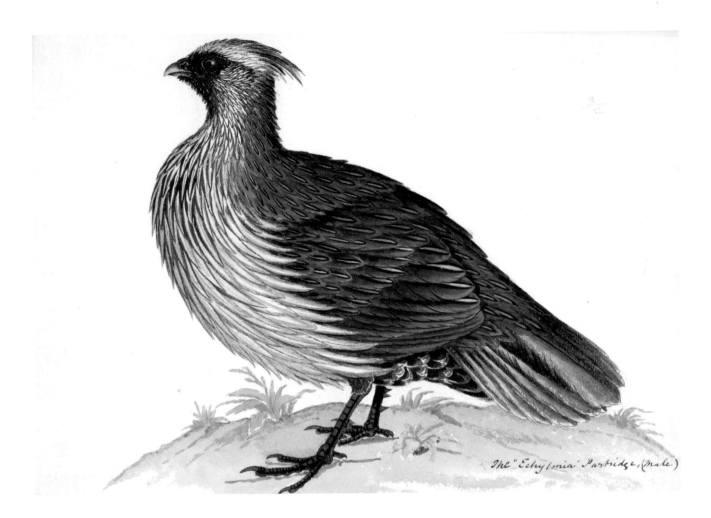

The "Echylmia" Partridge (male)

Ithaginus cruentus, blood pheasant

The artist has managed to capture the unusual compact, partridge-like appearance of the blood pheasant. This suggests the artist was familiar with the bird in life, and may well have been drawing from a living specimen.

Rajman Singh
Watercolour
1856–64
255 x 358 mm

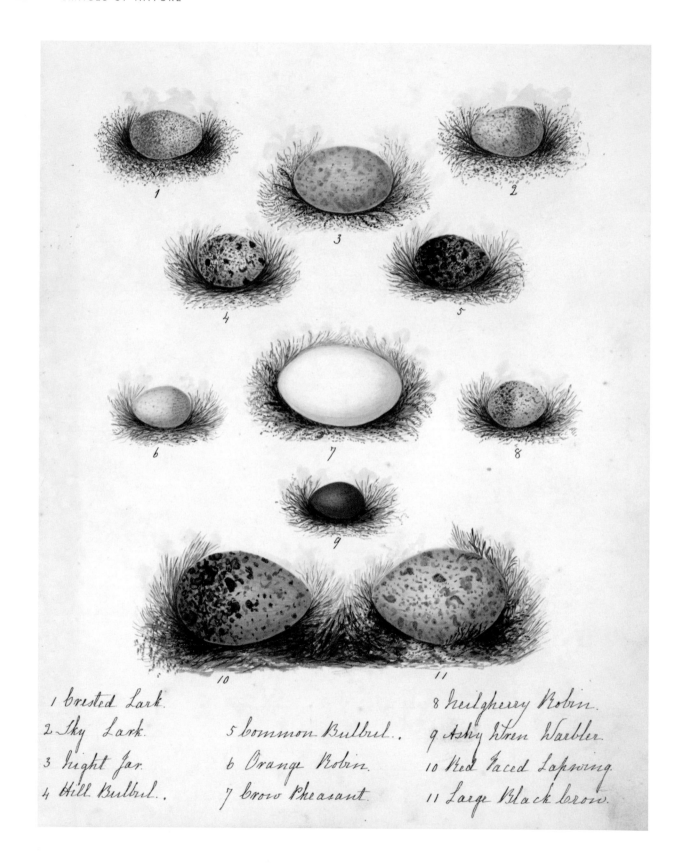

1 Crested Lark.

2 Sky Lark.

3 Night Jar.

4 Hill Bulbul.

5 Common Bulbul.

6 Orange Robin.

7 Crow Pheasant.

8 Neilgherry Robin.

9 Ashy Wren Warbler.

10 Red Faced Lapwing.

11 Large Black Crow.

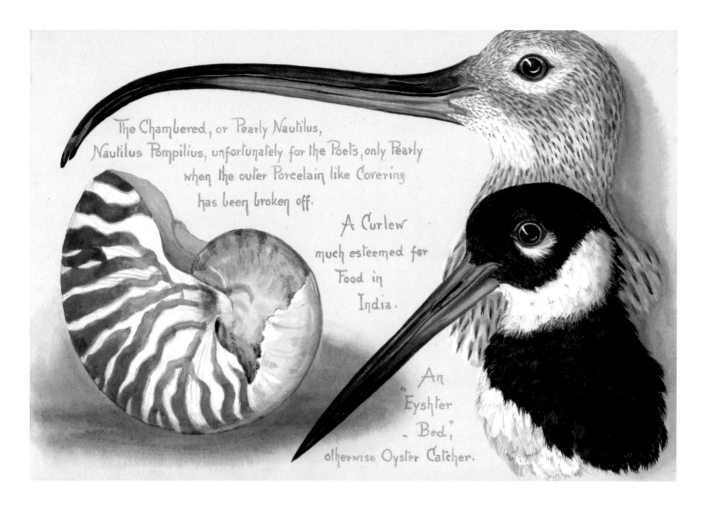

The Chambered, or Pearly Nautilus, Nautilus Pompilius, unfortunately for the Poets, only Pearly when the outer Porcelain like Covering has been broken off.

A Curlew much esteemed for Food in India.

An "Eyshter Bed", otherwise Oyster Catcher.

Eggs of birds from the Nilgiri Hills, southern India

Margaret Cockburn recorded the birds of the Neilgherry, now Nilgiri Hills, in both her art and writing. Her observations were often used by the renowned ornithologist Allan Octavian Hume. The Nilgiri Hills are now recognised as a UNESCO Biosphere Reserve, as crucial for their unique biodiversity.

Cockburn
Watercolour
1858
260 x 205 mm

Nautilus pompilius, Numenius arquata, Haematopus ostralegus, nautilus, Eurasian curlew, Eurasian oystercatcher

Both species of birds are principally winter visitors to coastal India, occurring together on the southern and western coastlines. The nautilus comes from the Pacific but dead specimens can be found on coastlines around the world.

Tonge
Watercolour
c. 1910–12
180 x 258 mm

Moorrug Munnowur

Tragopan satyra, satyr tragopan (immature male)

Tragopans were familiar in Indian menageries from at least the early seventeenth century. This bird is clearly a young male, which although has the distinctive spots, has yet to develop the crimson belly of an adult.

Indian miscellaneous Collection
Watercolour
c. 1820
536 x 449 mm

Hirundapus caudacutus, white-throated needletail

The first proper description of this bird was published in 1836 in the *Journal of the Asiatic Society of Bengal* by Hodgson. Needletails are large swifts, with unusual spines projecting from their short tails. They are summer visitors to the Himalayas.

Hodgson Collection
Watercolour
c. 1840s
474 x 290 mm

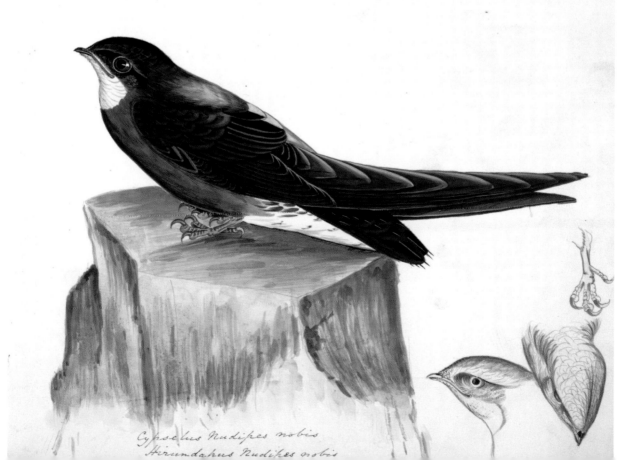

Cypselus Nudipes nobis
Hirundapus Nudipes nobis

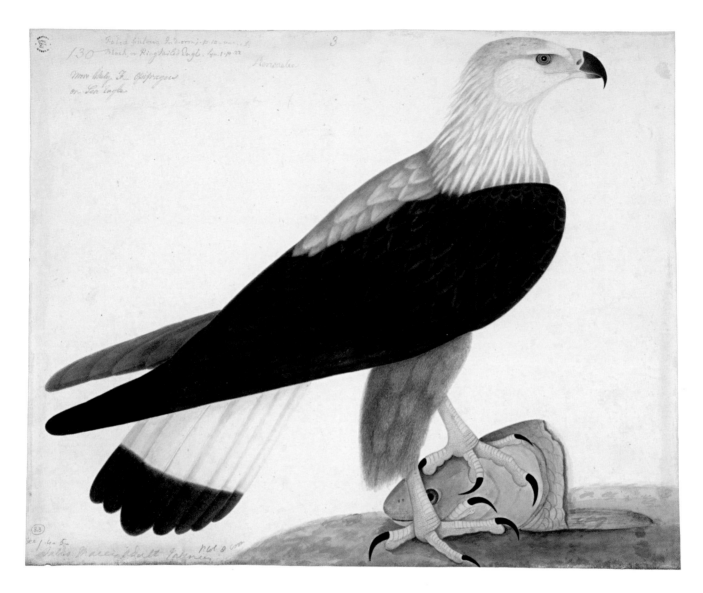

Haliaeetus leucoryphus, Pallas's fish-eagle

Also sometimes known as ring-tailed eagle, this large eagle has
a wingspan of about two metres. Its diet mainly consists of large
fresh water fish. It regularly attacks other water birds in order to
steal their catch.

Hardwicke Collection
Watercolour
c. 1820
470 x 577 mm

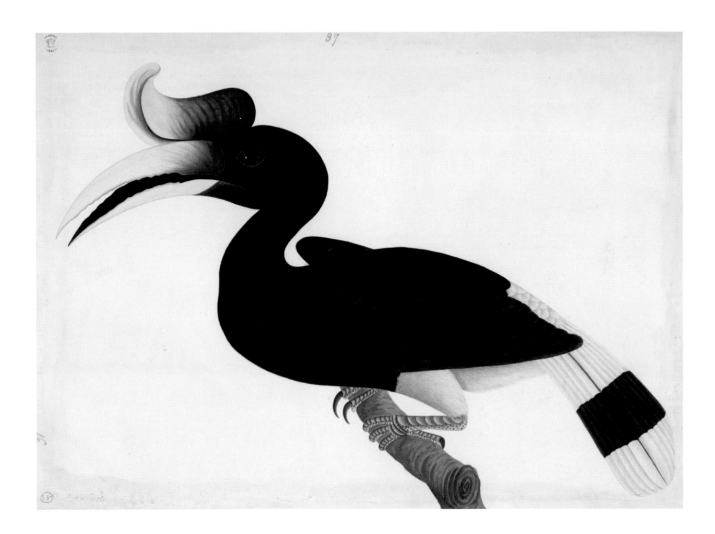

Buceros rhinoceros, rhinoceros hornbill

This stunning large hornbill is a native of Borneo, Peninsular Malaysia,
Java and Sumatra. Hornbill specimens were routinely traded into
the Indian subcontinent during the seventeenth and eighteenth
centuries.

Hardwicke Collection
Watercolour
c. 1818
385 x 524 mm

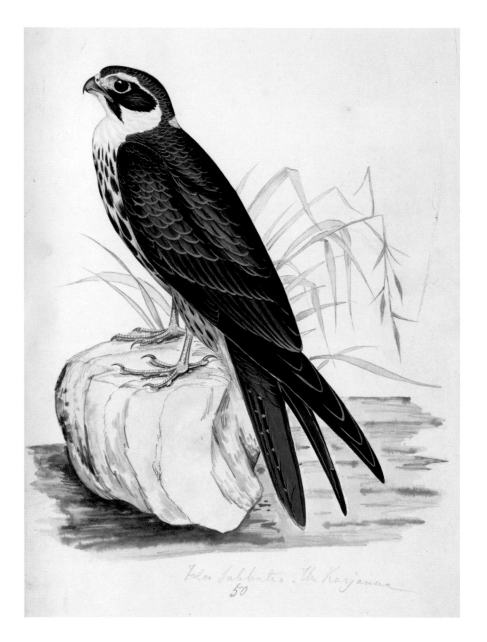

Falco subbuteo, Eurasian hobby

The Eurasian hobby is a summer breeding visitor to the Himalayas, also occurring widely across India as a migrant. It almost disappears from the region in winter.

Hodgson Collection
Watercolour
c. 1840
472 x 280 mm

Trachypithecus vetulus, purple-faced langur

'Drawn after the living animal. The Cingalays call it Wandoera'. This monkey is unique to Sri Lanka and was ubiquitous in the eighteenth century. Due to loss of habitat and food source its numbers have decreased considerably.

Bevere/Loten Collection
Watercolour
1752–57
492 x 380 mm

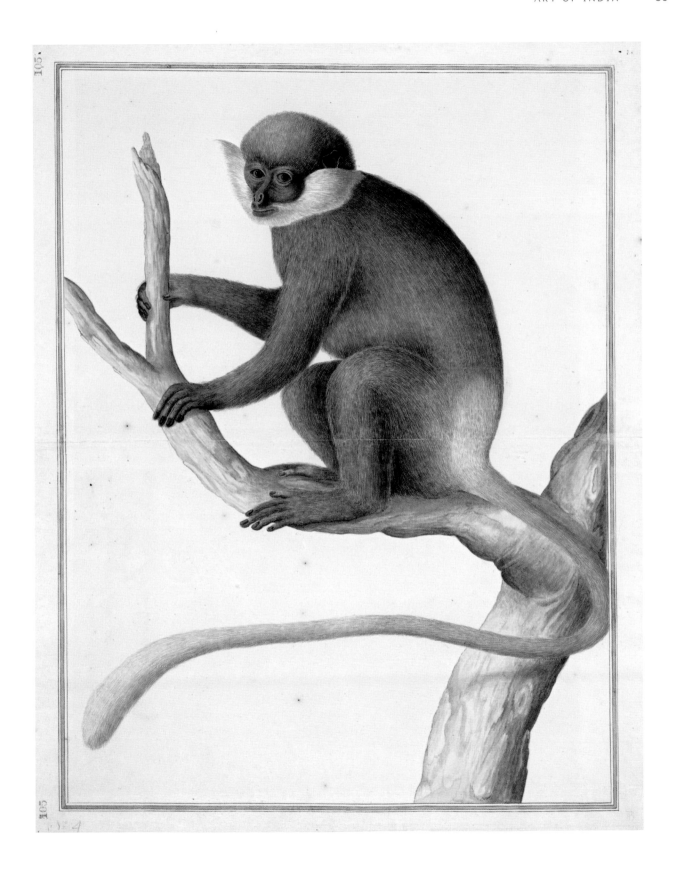

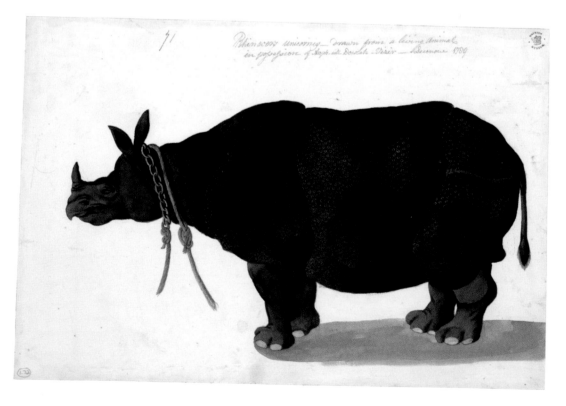

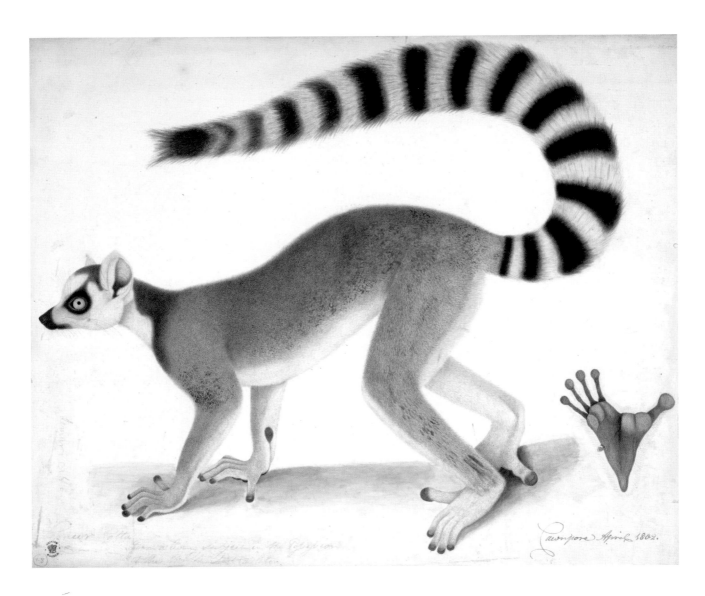

Rhinoceros unicornis, Indian rhinoceros

Drawn from a living animal in possession of Asoph-ud Dowlah
(Asif-ud Daula) who was the Nawab of the kingdom of Awadh
and who held court in Lucknow.

Hardwicke Collection
Watercolour
1789
254 x 383 mm and 292 x 427 mm

Lemur catta, ring-tailed lemur

This species is endemic to the island of Madagascar. Hardwicke had
this drawing made from a living specimen that was in the menagerie
of a resident of Cawnpore (now Kanpur).

Hardwicke Collection
Watercolour
1802
464 x 573 mm

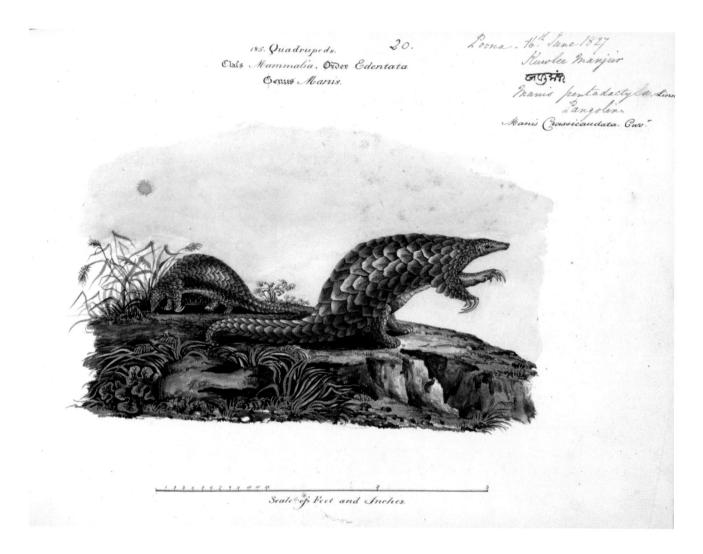

185. Quadrupeds. 20. Poona. 16th June 1827

Class Mammalia. Order Edentata Kuulee Manjur

Genus Manis. जपुझंभं

 Manis pentadactyla. Linn

 Pangolin.

 Manis Crassicaudata. Cuv.

Scale of Feet and Inches.

Manis crassicaudata, Indian pangolin

This nocturnal insectivorous animal is the only mammal with large
overlapping scales on its body that serve as protective armour.
The pangolin is found across India located wherever there is an
abundance of termites, its main food source.

Fidlor/Sykes Collection
Watercolour
1827
230 x 310 mm

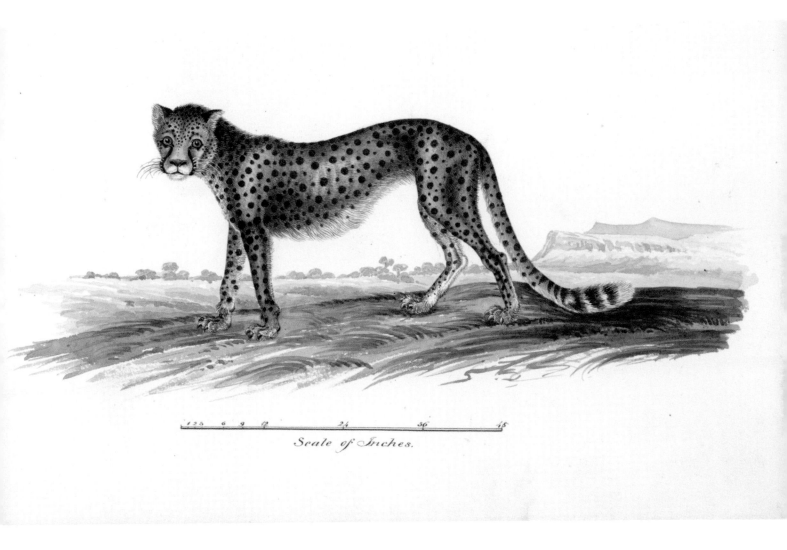

Scale of Inches.

Acinonyx jubatus, cheetah

The cheetah is now extinct in India but in the early nineteenth century when this drawing was made it was fairly common. Its decline was mainly due to hunting, habitat development and a decrease in its prey.

Fidlor/Sykes Collection
Watercolour
1828
266 x 365 mm

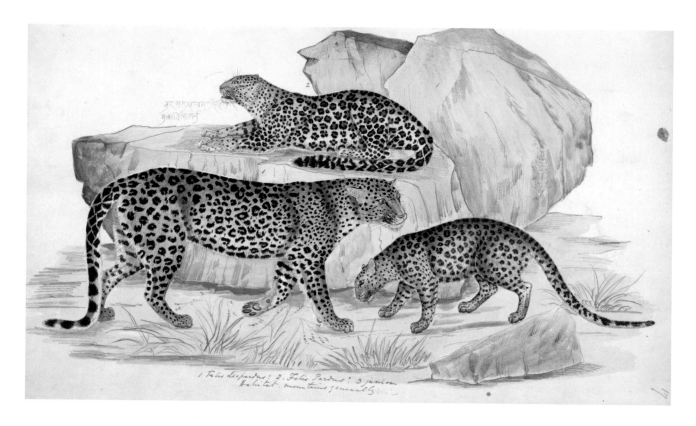

Panthera pardus, leopard

Loss of habitat and excessive hunting has caused a dramatic
decline in the population of the leopard since this drawing was
made. It is listed as 'near threatened' by the International Union for
Conservation of Nature (IUCN). Nevertheless, it has proved a little
more successful than other large cats in the Indian subcontinent.

Hodgson Collection
Watercolour
c. 1840s
290 x 475 mm

Galeopterus variegates, Sunda flying lemur

Like many of Hardwicke's drawings this species is not found in
India but is native in other parts of Southeast Asia. It is not a lemur
nor does it fly, but glides by the use of a membrane flap attached
between its limbs.

Hardwicke Collection
Watercolour
c. 1820
379 x 437 mm

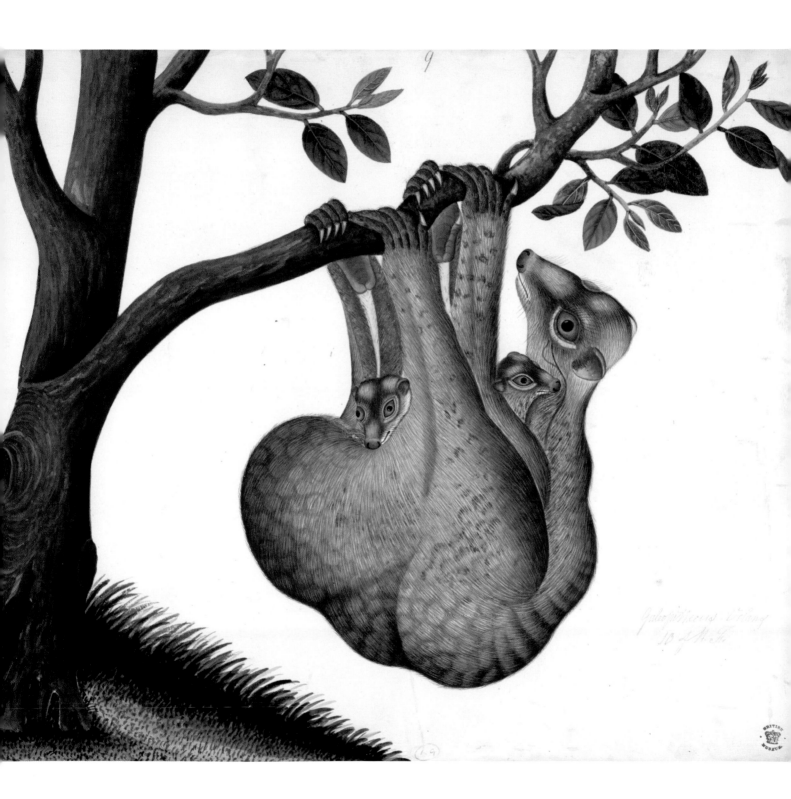

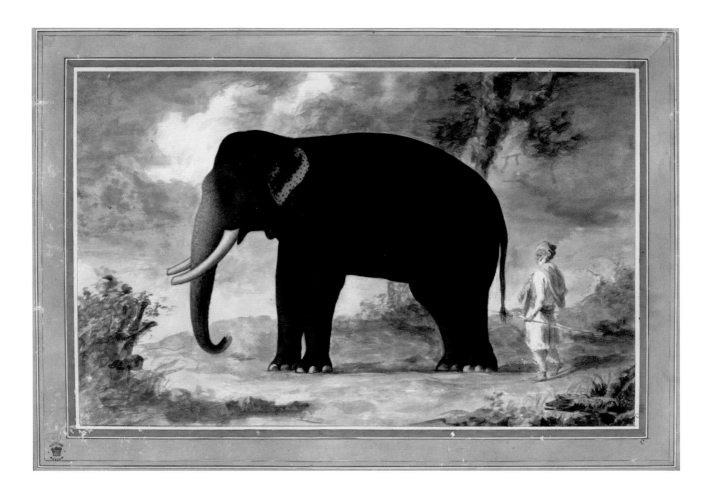

Elephas maximus, Indian elephant

One of a few drawings that are given a full background setting and
framed as a picture rather than a scientific drawing. The Indian
elephant is listed as endangered mainly as a result of habitat loss.

Hardwicke Collection
Watercolour
c. 1820
346 x 504 mm

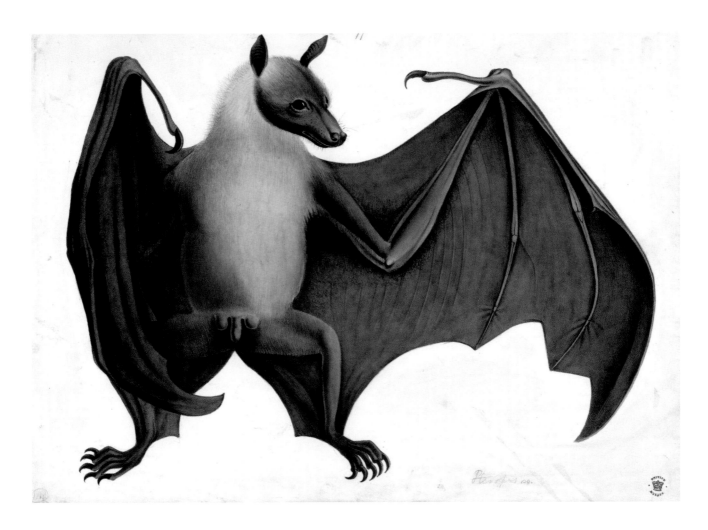

Pteropus sp., flying fox

Flying foxes are large bats found in the sub-tropical parts of Asia, Australia and islands off East Africa. They are called fruit bats as they feed only on fruit, pollen and nectar.

Hayes/Hardwicke Collection
Watercolour
c. 1832
394 x 467 mm

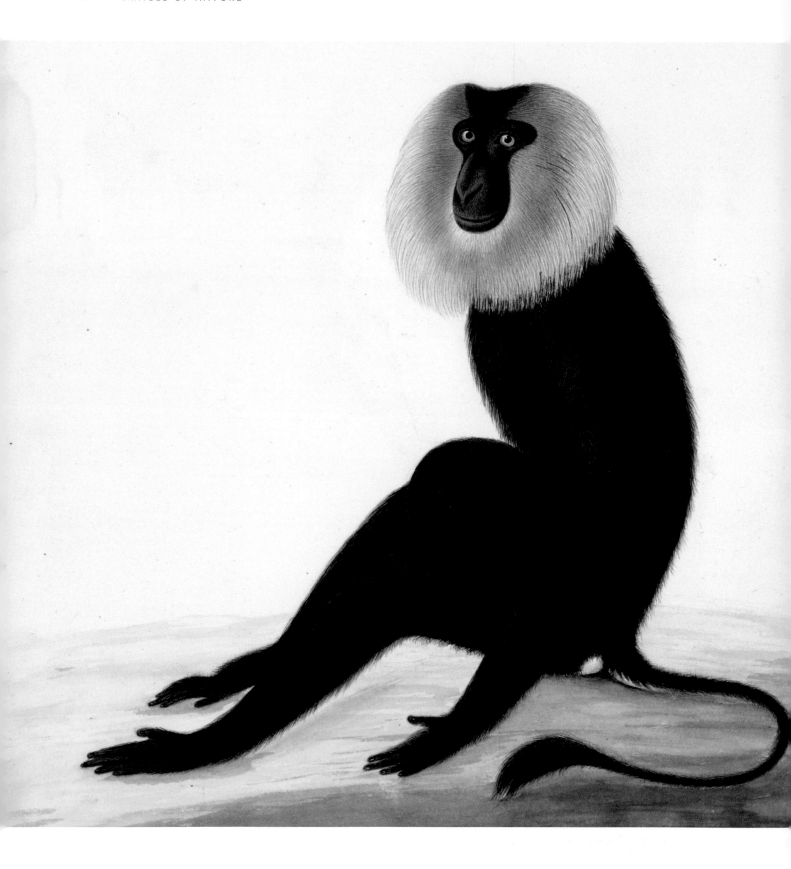

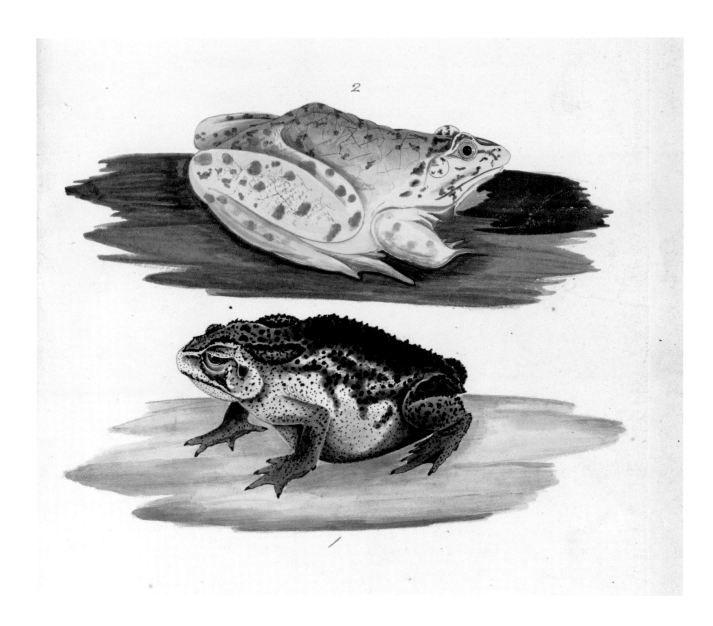

Macaca silenus, lion-tailed macaque

This distinctive looking silver-maned macaque lives in the rainforests of southwest India. They spend much of their time in the canopies of the forest feeding on fruit, leaves and insects.

Hardwicke Collection
Watercolour
c. 1820
356 x 250 mm

Frog and toad

Hodgson's interest lay primarily in avian fauna. However, among his drawings are a few reptiles and even fewer amphibians. Here are two, the common frog and common toad from the central region of Nepal.

Hodgson Collection
Watercolour
c. 1840s
475 x 290 mm

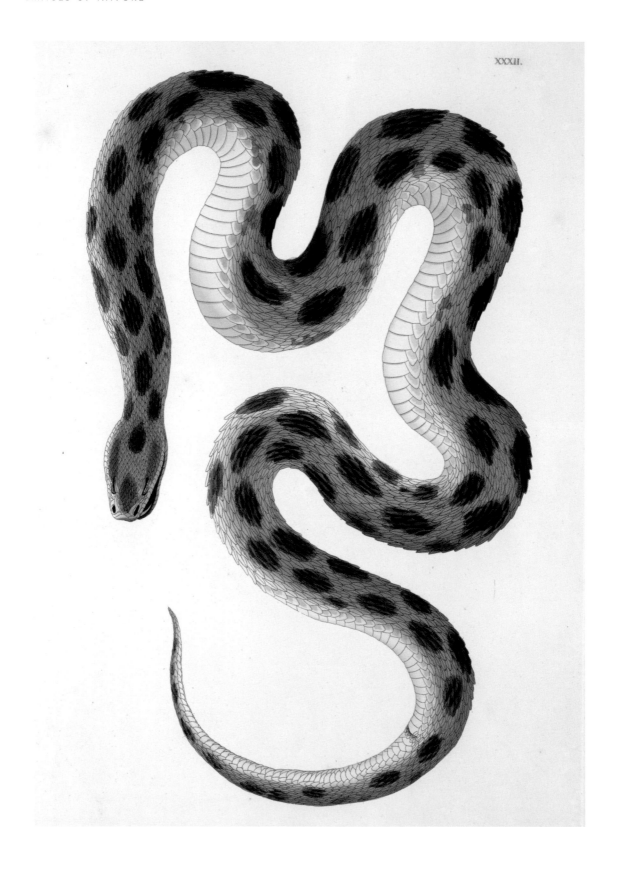

XXXII.

The size of Nature.

Daboia russelii, Russell's viper

This venomous snake is named after Patrick Russell and is included in volume two of *An Account of Indian Serpents*. Russell was the first European to specialise in studying the snakes of India and was especially interested in recording all the poisonous snakes.

Engravin/Russell Collection
Watercolour and engraving
1801–09
445 x 300 mm

Chamealeo zeylanicus, Indian chameleon

The important external features necessary for identification are all present in this drawing, including the bifid clasping feet, the crests on the bony casque of the head, a prehensile tail and the darker bands across the back.

Fidlor/Sykes Collection
Watercolour
1827
265 x 365 mm

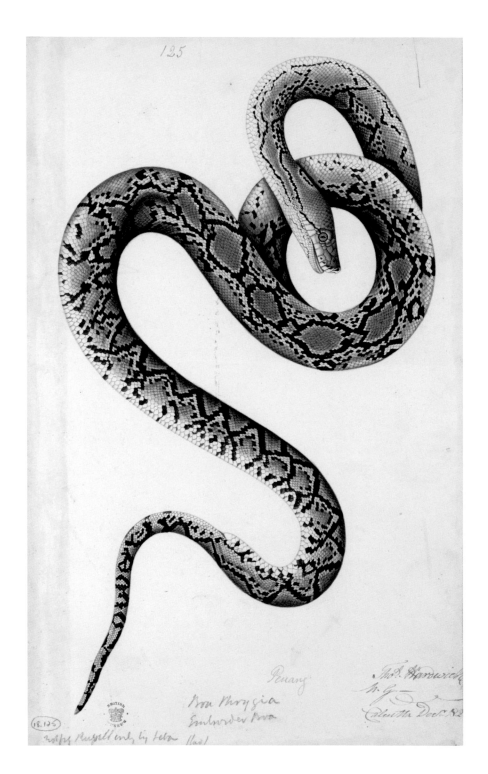

Broghammerus reticulatus, reticulated python

The reticulated python is the world's longest snake and found across most of Asia. This particular specimen came from Penang, which was another trading island controlled by the East India Company. The snake was probably dead when sent to Hardwicke.

Hardwicke Collection
Watercolour
1821
397 x 243 mm

Bungarus fasciatus, banded krait

Patrick Russell received a sickly specimen of this snake and relates an experiment he undertook in which he forced the jaws of the snake open and placed a leg of a live chicken there to be bitten. The chicken died within 26 minutes. Russell believed the venom would have had a much quicker effect if the snake had been healthier.

Indian miscellaneous Collection
Watercolour
c. 1820
380 x 474 mm

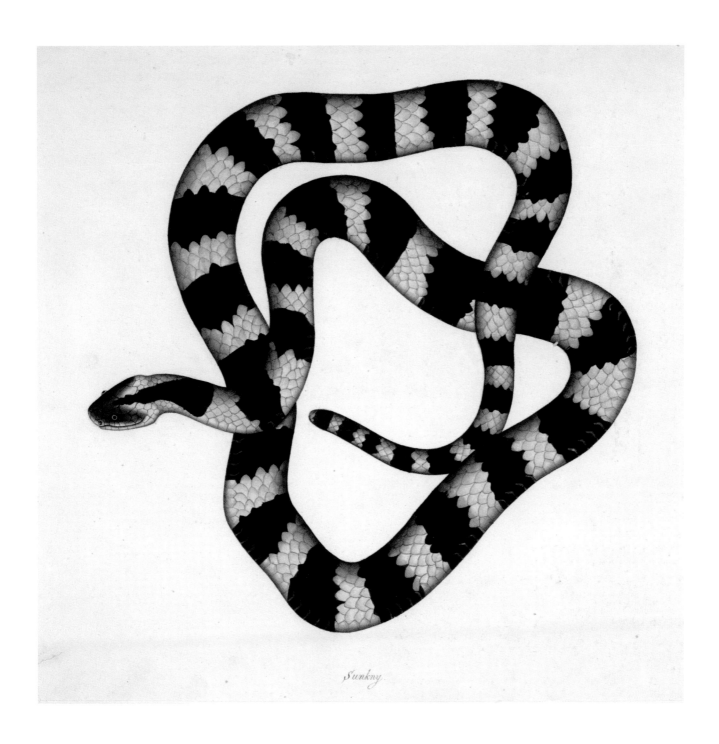

Sunkny.

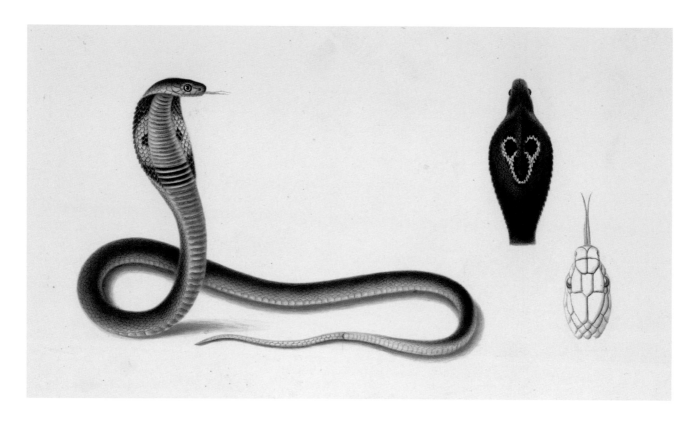

Naja naja, Indian cobra

'A very young subject – extremely active & dangerous'. This cobra is depicted in its distinctive hooded pose, a characteristic display when under threat.

Hardwicke Collection
Watercolour
c. 1817
240 x 414 mm

Poecilotheria, tarantula

The species of tarantula in this genus are arboreal and usually have a more potent venom than other tarantulas.

Hardwicke
Watercolour
c. 1820s
270 x 205 mm

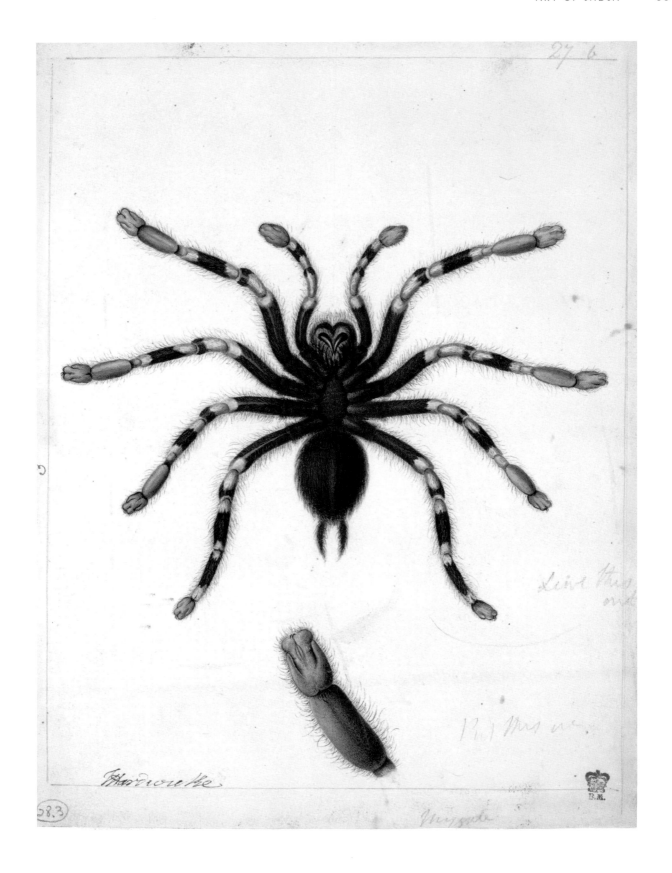

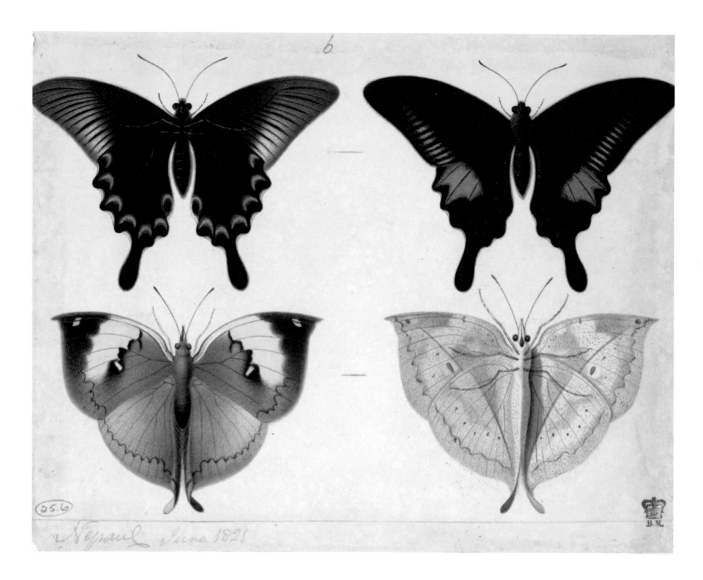

From top and l-r: *Papilio arcturus arcturus*, *Papilio polyctor ganesa*, *Kallima inachus inachus*, blue peacock, common peacock swallowtails and Indian leaf butterfly

These beautiful butterflies and bees are native to India and found in several regions including the Himalayas. All the specimens depicted in both drawings are from Nepal but it is unknown whether the artist J. Hayes travelled to Nepal or received specimens from other collectors from that area.

Hayes/Hardwicke Collection
Watercolour
1821
185 x 230 mm

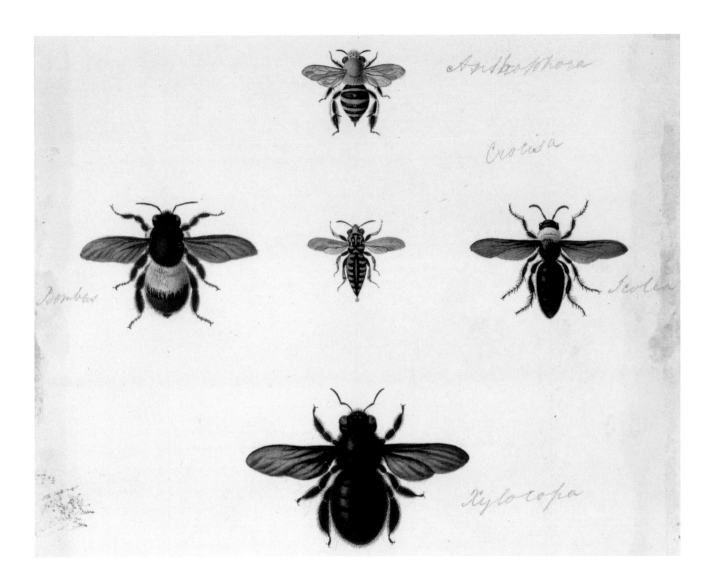

From top and l-r: *Amegilla, Bombus, Thyreus, ?Andrena, Xylocopa*, bee, bumblebee, parasitic bee, solitary bee, carpenter bee

Hayes/Hardwicke Collection
Watercolour
1821
248 x 198 mm

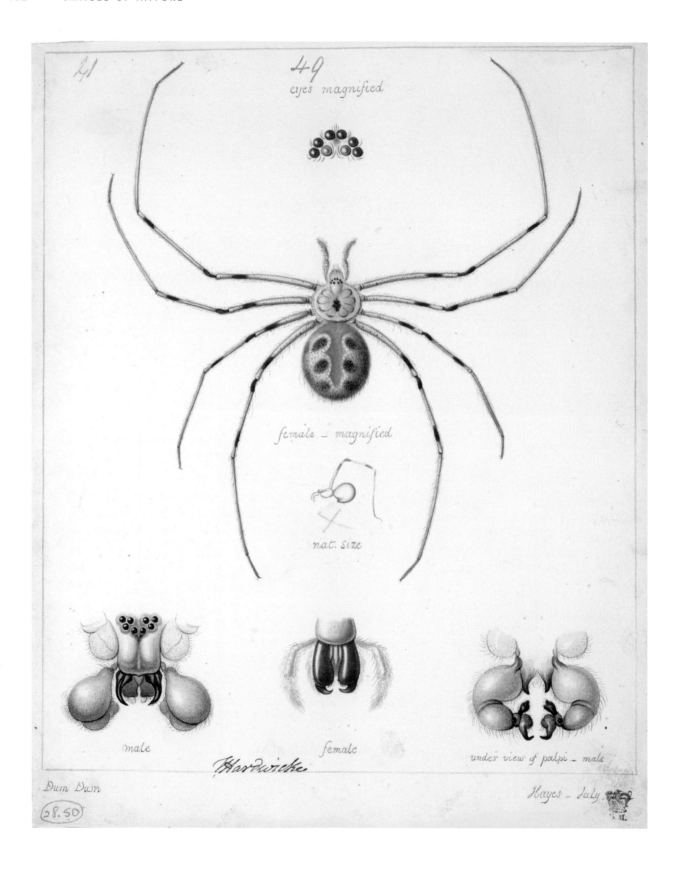

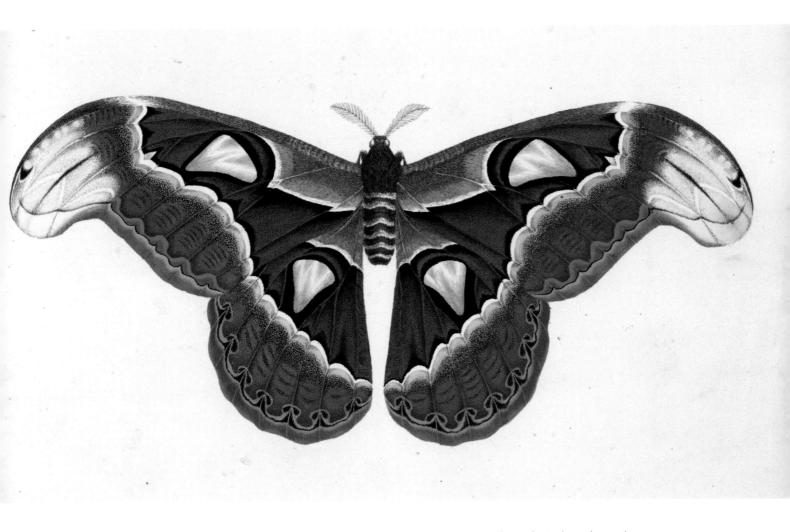

Spider

This spider is difficult to identify despite the detailed depiction of the male and female organs, the positioning of the eyes and all features drawn under magnification. It is possibly from the Nesticidae family.

Hayes/Hardwicke Collection
Watercolour
1822
270 x 212 mm

Attacus taprobanis, Sri Lankan atlas moth

This magnificent large moth was drawn in Bombay from a specimen 'caught at Dappoolee, Southern Konkun'. The Sri Lankan atlas moth has one of the largest wingspans of all moths and is found only in the Western Ghats and Sri Lanka. It is closely related to the atlas moth, *Attacus atlas*, which occurs throughout much of Southeast Asia.

Fidlor/Sykes Collection
Watercolour
1826
230 x 310 mm

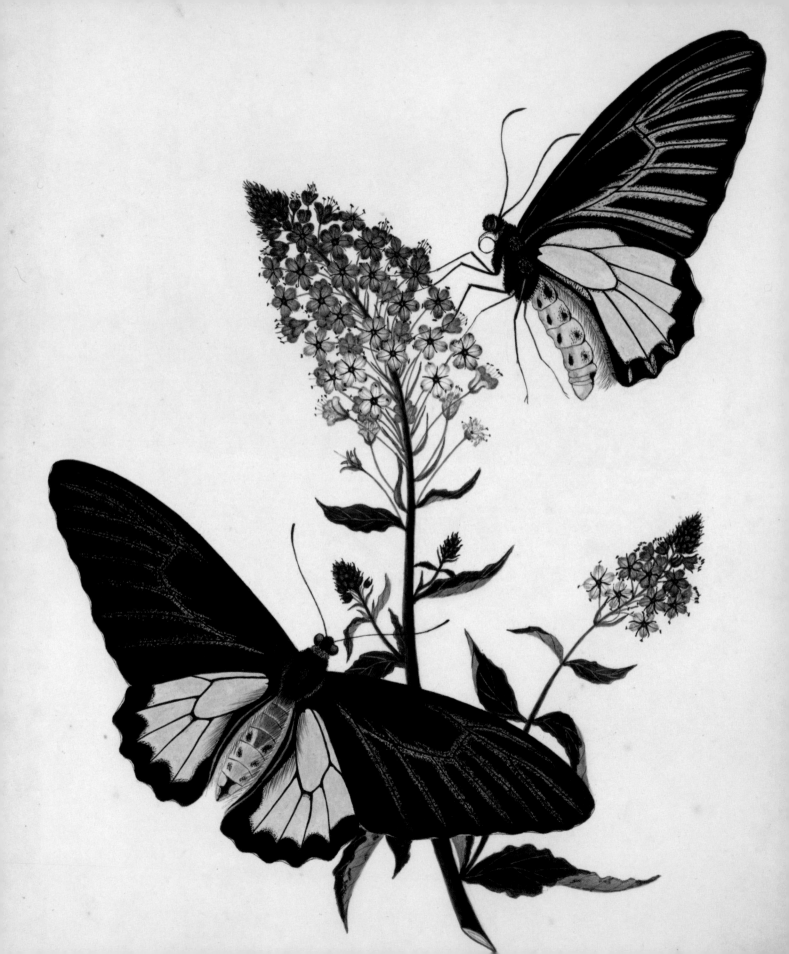

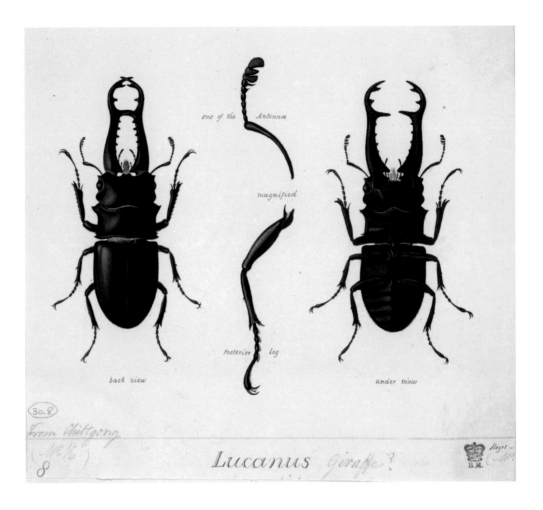

Troides minos, southern birdwing butterfly and *Lysimachia leschenaultii*

Margaret Cockburn's interest in natural history included collecting specimens and she presented her butterfly collection to the Natural History Museum in London. Although the adults of this butterfly species might feed on the flowers *Lysimachia leschenaultii* depicted its larva feeds on the leaves of the *Aristolochia tagala* plant.

Cockburn
Watercolour
c. 1858
260 x 205 ᵐᵐ

Prosopocoilus (Cladognathus) giraffa, stag beetles

This magnificent drawing of the stag beetle, so called because of its antler-like mandibles, shows its upper and underside and magnified leg and antenna. The specimen was collected in Chittagong, now a city in Bangladesh.

Hayes/Hardwicke Collection
Watercolour
c. 1820
185 x 200 mm

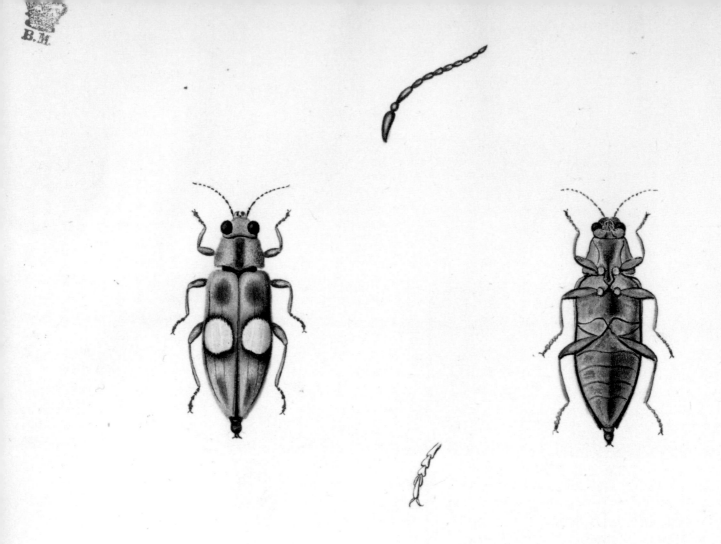
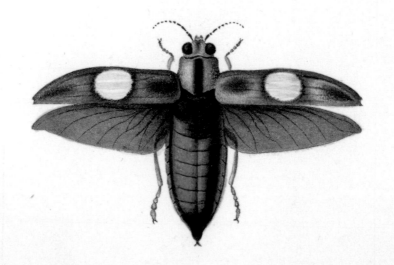

Chrysochroa ocellata, jewel beetle

These colourful jewel beetles were collected at Dum Dum in West Bengal, the home of the Bengal artillery and where the artist Hayes made many of his drawings.

Hayes/Hardwicke Collection
Watercolour
c. 1820
255 x 167 mm

Phyllium (Pulchriphyllium)
bioculatum, Javanese leaf insect

The male leaf insect is distinguished by its long hind wings, which enable it to fly. Depicted here are flightless females.

Hayes/Hardwicke Collection
Watercolour
c. 1820
278 x 196 mm

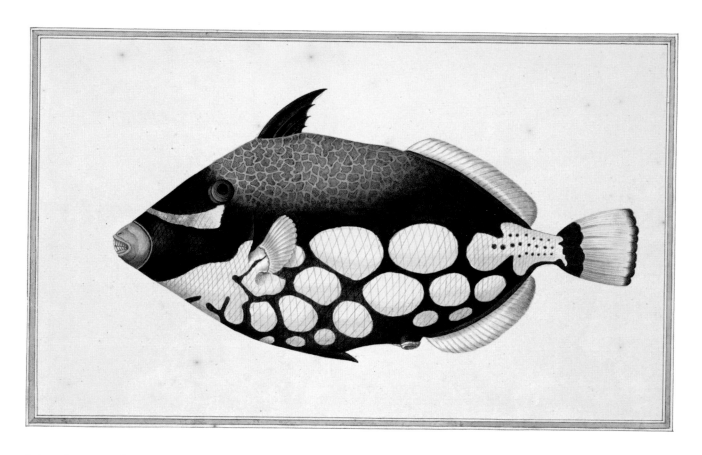

Balistoides conspicillum

This fish is described as '1 foot 3 inches long and very good to eat'.
The Sinhalese name was Pottoebora.

Bevere/Loten Collection
Watercolour
1752–57
249 x 384 mm

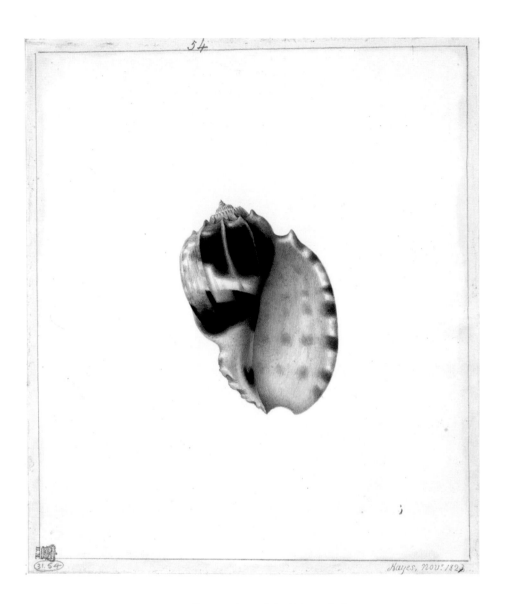

Harpa cabritii, Cabrit's harp shell

This shell is found in the Indian Ocean. It was named for Monsieur Cabrit from Bordeaux who was a collector and dealer of natural history specimens in the eighteenth century.

Hayes/Hardwicke Collection
Watercolour
1823
253 x 216 mm

Cyprinus abramioides

In his report on the fish of the Deccan region Sykes wrote that of
the forty-six species he described forty-two were new to science.
Sykes named this fish *Cyprinus abramioides* in his paper for the
Proceedings of the Zoological Society of London in 1838.

Fidlor/Sykes Collection
Watercolour
1827
266 x 365 mm

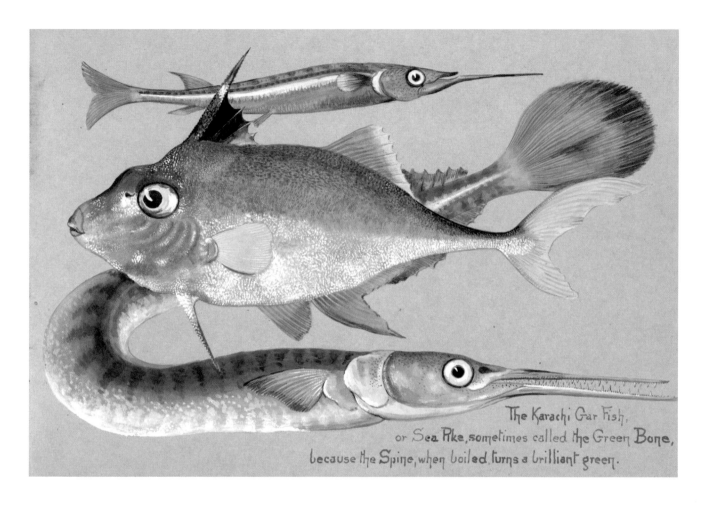

The Karachi Gar Fish, or Sea Pike, sometimes called the Green Bone, because the Spine, when boiled, turns a brilliant green.

Family Hemirhamphidae, halfbeak, *Triacanthus* sp., tripod fish, Family Belonidae, garfish

Olivia Tonge accompanied most of her drawings with descriptive text. Here she tells of the green bones of the garfish – a characteristic of this species. They are highly prized as food by those not deterred by this.

Tonge
Watercolour
c. 1910–12
180 x 258 mm

Index